IMAGES
of America

IRISH BUTTE

"Now don't forget, Lizzie, when you get to the new world, don't stop in America. You go straight to Butte, Montana."

Mary Hagan

This old saying from Ireland by Mary Hagan illustrates the attitude across the Atlantic towards Butte as an Irish destination. (Picture of embossed granite at the Butte Silver Bow Archives courtesy of Maureen Bowman.)

ON THE COVER: Around 1949, these Irish lads and lassies took a break from winter sledding to pose in front of Skuck Shea's shed in Dublin Gulch. (More of the story can be found on page 58).

IMAGES
of America

IRISH BUTTE

Debbie Bowman Shea

ARCADIA
PUBLISHING

Published by Arcadia Publishing
Charleston, South Carolina

Printed in the United States of America

Library of Congress Control Number: 2010934151

For all general information, please contact Arcadia Publishing:
Telephone 843-853-2070
Fax 843-853-0044
E-mail sales@arcadiapublishing.com
For customer service and orders:
Toll-Free 1-888-313-2665

Visit us on the Internet at www.arcadiapublishing.com

Dedicated to all who are Butte Irish:
for wherever their home, their heart is forever in Butte.

CONTENTS

ACKNOWLEDGMENTS

This collection of wonderful photographs, valued treasures that come to life in print after many years in albums, boxes, and hope chests, has been generously donated by Butte Irish who acknowledge the sacrifice of those that came before them and continue to absorb the fruits of their labor. I thank all of you for your generous donations.

To the Butte Silver Bow Archives, Ellen Crain, Lee Whitney, Harriet Schultz, and to Dolores Cooney at the World Museum of Mining, I say thank you for your immeasurable contribution to this book and to our community.

A special thank you to Fr. Gregory Burke for your wonderful Irish spirit and remarkable historic perspective, to Bina Bowman Eggensperger for your editorial eye, to childhood friend Peggy Walters Stadler for nights of typing and keeping me focused, to Maureen Bowman for your photography expertise, to Julie Crowley for your enthusiasm and photographs (as the one behind the camera rarely gets in the picture), to the wonderful Coleman family who invited me for tea to share their stories of being the only Norwegian family on Anaconda Road, to the late Fr. Sarsfield O'Sullivan for his gracious hospitality and entertaining stories, to my grandfather Mike Healy's dear friend Kevin Shannon for your delightful and humorous tales of living on the hill, to Tom Kelly and Vince Downing for your memories, and to cousins Mary and John Crowley from Kilworth in County Cork, Ireland, for Irish translation.

Finally to John Poultney and the fine folk at Arcadia Publishing, thank you for your patience and this opportunity to tell but a small part of the remarkable story of Irish Butte.

INTRODUCTION

If on every ocean the ship is a throne / And for each mast cut down another sapling is grown / Then I could believe that I'm bound to find / A better life than I left behind / But as you ascend the ladder / Look out below where you tread / For the colors bled as they overflowed / Red, white and blue / Green, white and gold / So I had to leave from my country of birth / As for each child grown tall / Another lies in the earth / And for every rail we laid in the loam / There's a thousand miles of the long journey home / But as you ascend the ladder / Look out below where you tread / For the colors bled as they overflowed / Red, white and blue / Green, white and gold

"Long Journey Home"
—Elvis Costello and Paddy Moloney for *The Irish In America* project

And so their journey began . . .

Through the late 1800s well into the 19th century, Irish emigrants hailing from every county of Ireland journeyed to the mining camp of Butte, Montana. Booking passage, those destined to change the course of history set sail from crowded ports that included Cork, Donegal, Mayo, and Wexford. They left a beloved, but impoverished, Ireland in search of a better life. Crossing the Atlantic was not an easy passage, as most Irish immigrating to North America could ill afford first- or second-class accommodations. Assigned to steerage, the cheapest and most crowded space on the lower deck of the ship, third-class passengers found their voyage a long and arduous one. Landing on the eastern shores of North America, relatives and friends who had sponsored their immigration greeted the weary travelers and for many Irish their long journey had come to an end. Those seeking work in Butte, Montana, however, would find the end of their journey another 2,000 miles across the country.

Ireland had long been associated with mining. Prompted by a call of the first and second wave of the Industrial Revolution, almost every county in Ireland had a metal producing mine, the copper mines of Allihies in West Cork among them. It was during the second wave that Irish son, copper king Marcus Daly from County Cavan, Ireland, discovered the richest vein of copper in the world in Butte, Montana. Intelligent and ambitious, Daly was sent to Butte by the Walker Brothers to assess the Alice Silver mine. Confirming the value of the Alice mine, Daly himself invested money in the enterprise and soon realized a sizeable profit. With a keen mind and a bit of Irish luck, he then purchased the Anaconda silver mine from Irishman Michael Hickey. This would cause a feud between the Northern Pacific (NP), Walker Brothers, and Daly. Because of a hike in freight rate with the NP, Daly would then build the Butte, Anaconda, and Pacific Railroad (BA&P).

Staking claim to his destiny with help from backers like George Hearst (grandfather of famed publisher William Randolph Hearst), Daly teamed with Rockefeller's Standard Oil and others to establish the Amalgamated Copper Mining Company, later to become the Anaconda Company.

Huge deposits of ore were found in that venture overlooking the Summit Valley, and it was quite timely that Alexander Graham Bell had just invented a telephone using copper wire to transfer sound, and Thomas Edison had just set the world on fire with his discovery of the incandescent light. The demand for this ductile element was massive, and overnight Marcus Daly became a multimillionaire.

With a fall in world-wide metal prices and ongoing labor conflicts, many Irish mines shut down operations, and areas like Allihies saw large-scale immigration to Butte. Because of the large number of emigrants leaving Ireland for the "Mining City," Butte became known as "Ireland's Fifth Province." Arriving in a city that did not sleep, Irish immigrants found work in the mines and a haven in the many boardinghouses that dotted the span of the hill. Entrenched, they soon staked claim to that hill, and Irish neighborhoods like Dublin Gulch, Corktown, Sunnyside, Centerville, Walkerville, and Muckerville sprang up around the gallows frames that dropped men a mile below the earth's surface.

Surrounding himself with his countrymen, Marcus Daly ensured work and fair wages for the many Irish immigrating to Butte. But the working conditions of underground mines were dangerous, and the Irish, placing "safety in the hands of God," exceeded all ethnic groups in mining fatalities. If a "duggan" or fallen rock didn't take them, respiratory diseases that included tuberculosis and consumption lent a hand, making young widows of many Irish brides. The term "duggan" comes from Duggan mortuary.

The Irish not only ran the mines of Butte but found opportunity in every field of work—miners and mine superintendents, political positions, business professionals, merchants, bar owners, bootleggers, policemen, firemen, clergy, and domestics. Linked by a common thread, all served to drive the Butte economy and ensure Irish influence. Irish matriarchs were the center of the Irish family, but more noteworthy, the nucleus of the larger Irish community. Their strength of character is the subject of poets; their passing, the lament of grown men. It was these wonderful women who tied the Old World to the New and instilled an Irish consciousness that kept family, faith, and neighborhoods intact.

Faith and the Catholic Church was for the Butte Irish much the same as in Ireland, the center of their world. Recruiting priests from the homeland, Irish parishes like St. Lawrence O'Toole, St. Mary's, and St. Patrick's, built in the heart of the mining district, secured for the Irish their social and spiritual life. Parochial education was encouraged among Irish families with an emphasis on studies and sports. Irish nationalism had a stronghold, early on, in the mining camp, undermining the Irish debasement that threatened many large eastern cities. Visits by Irish dignitaries, like Eamon de Valera and Mary McSwiney, fueled the fires for an independent homeland.

Irish fraternal organizations, the Democratic Party, and the miners union gave strong voice to a people that had long been oppressed under British rule. Butte was known as the Gibraltar of Unionism. The Butte Workingmen's Union was founded in 1878 and became Local No. 1 of the Western Federation of Miners. Many other unions followed including the Metal Mine Workers Union, the contentious International Workers of the World, and the Woman's Protective Union led by Bridget Shea.

Today over a quarter of Butte's citizens claim Irish ancestry and commemorate their heritage and its historical importance with cultural study and celebration. Irish dignitaries continue to visit the Mining City fostering Irish alliance. The annual St. Patrick's Day parade and festivities honor the saint, highlighting the Irish spirit, sense of humor, and love of life. An Ri Ra, the annual Irish festival, offers cultural workshops and days and evenings of Irish dance and music. Irish organizations like The Friendly Sons of St. Patrick and the Ancient Order of Hibernians (AOH), for women and men, continue the age-old direction of promoting the best of Irish mores. Through the Miner's Memorial Project, the Memorial Garden at the World Museum of Mining honors all of Butte's fallen miners, almost half of which were of Irish ancestry. Valuing its historic architect on the hill, many of the Butte buildings and churches that once housed Irish families and workers and comforted the Irish in faith have been preserved and newly assigned.

Beannacht De (God's blessings) on all who braved the new world searching for a better life.

One

Tosnú na h-Oidhreachta

Beginning the Legacy

In 1876, twenty years after leaving County Cavan, Ireland, legendary copper king Marcus Daly came to Butte on behalf of the Walker Brothers of Salt Lake City, Utah. With a mission to explore the silver potential of the Alice mine, Daly and his wife, Maggie, moved to Butte and stepped into history. The Irish miner was paid good wages, but the risks of mining were devastating. Almost half of miners killed underground were of Irish ancestry. Along with the dangers of mining came the reality of young Irish widows. Little formal education would challenge these Irish women's ability to keep the home fires burning, but that determined Irish spirit saw most through the worst of times. Many widows became domestics or worked in laundries or stores. For those who struggled to keep their children safe and fed, the Paul Clark Home offered respite. The Catholic Church played a significant role in the life of Butte Irish. Irish priests were sent to oversee the Irish churches that stood proudly among the gallows frames on the hill. Between 1886 and 1921, visits to Butte from Irish nationalist leaders were in abundance. Patriots Eamon de Valera, president of the Provisional Irish Republic; scholar Douglas Hyde, who would serve as Ireland's first president; and Mary MacSwiney, sister of Irish martyr Terence MacSwiney, found a city where the Irish language was spoken, Irish dancing and music revered, and Irish Gaelic football played. Those years of immigration and colonization resulted in crowded Irish neighborhoods and explosive times within the mining industry, but the industrial and often rowdy city of Butte was for the Irish to define. Being the first to arrive, the Irish established the character and direction of Butte.

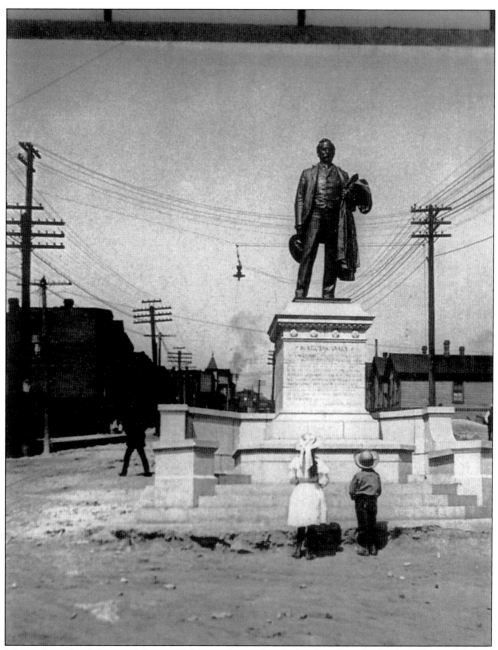

Throughout his lifetime, Marcus Daly was devoted to Ireland and to the Irish of Butte. Marcus Daly died in November 1900, his obituary from the *Butte Miner* reads: "A true empire builder, a friend to his friends, to his enemies remorseless and unforgiving. Daly, a father figure watched over his family, his friends and his employees with a heartfelt benevolence. When he ran the Anaconda Mining Company, he treated his employees better than most corporations of the time. More than any other man, he built the Montana mining industry, he was a true son of Ireland, which he never forgot and helped." (Courtesy of the Butte Silver Bow Archives.)

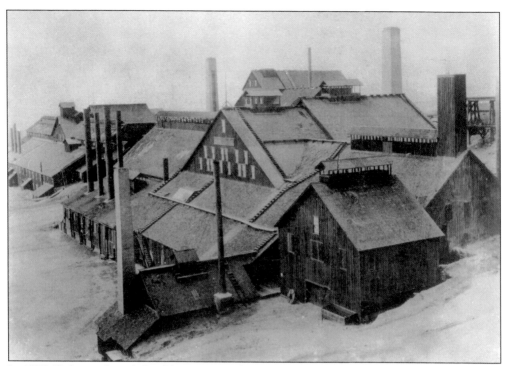

In 1876, Daly purchased the Alice mine and successfully managed it for the Walker Brothers. The town of Walkerville would spring up around the mine and mill. In 1880, Daly would sell his interest and purchase the Anaconda mine. Daly also founded the town of Anaconda near the smelter he built west of Butte. (Courtesy of the World Museum of Mining.)

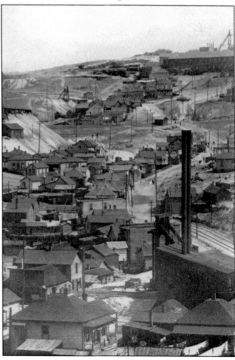

With promise of work and good wages, Daly recruited a workforce of Irish to man the mines of Butte. Hearing the call from County Cork to Donegal and from the coal mines of Pennsylvania to the copper mines of Michigan, they came to work the copper mines that spanned the hill. Sisters and brothers, cousins, friends, and strangers—all with promise of work and a better life— moved into Dublin Gulch, Corktown, Centerville, Walkerville, and Muckerville. (Courtesy of Butte Silver Bow Archives.)

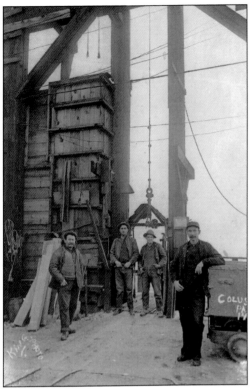

John Shea (right) and unidentified fellow workers stop to pose for a picture around 1920 before going underground for the afternoon shift at the Colusa mine. According to Fr. Gregory Burke, it was commonplace for Irish miners to pray the Act of Contrition before going underground and to give thanks to God upon safe return to the surface. (Courtesy of Carol Driscoll Brown and Shelly Hoar.)

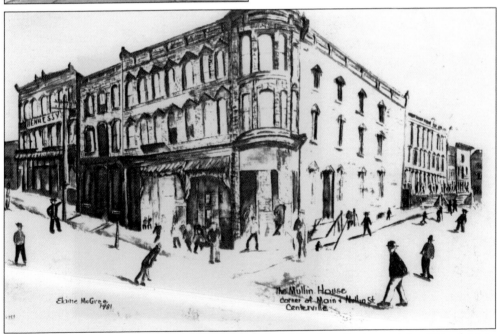

Nora and Patrick D. Harrington owned and operated the Mullen boardinghouse right off North Main Street. The Mullen House, shown above, was the largest of Butte's boardinghouses, accommodating 400 single miners, with several miners on different shifts sharing the same bed. (Sketch by Elaine McGree; courtesy of Frank Grady.)

Mary Buckley was born in Macroom, County Cork, Ireland, in 1875 and came to America at 18. Mary's maiden name and married surname were the same as she married Mike Buckley, also an immigrant from Macroom. This union produced six children. Mike worked in the mines, and Mary ran and ruled the Buckley boardinghouse on Wyoming Street. She fed and housed 17 to 20 men and provided meals for 30 to 40 others, mostly of Gaelic origin. (Courtesy of Mary Lou Mansanti.)

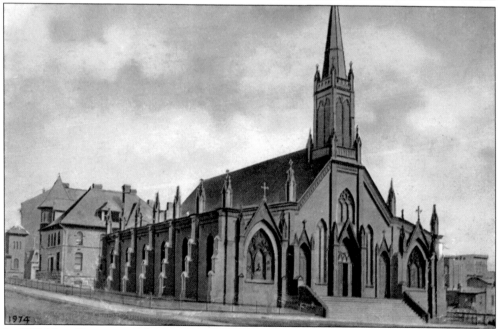

In 1910, Nora Harrington, who ran a boardinghouse on Belle Street, wrote this postcard to boarder Michael Healy, who had temporarily moved to Utah because of a labor dispute in Butte. The postcard of St. Patrick's Church reads, "This is to put you in mind of your duty. I suppose you haven't been in church since you left here. I got your letter and postal, glad you are getting along well. Butte is just the same. Good bye, Mrs. J Harrington." Nora was wife to Jerry and mother to Joe, Mary (Hannifan), Jerry, Agnes (Holland), and Helen (Steele). (Courtesy of Enda Healy Bowman.)

13

Thomas and Bridget McGrath on their wedding day at St. Patrick's Church in 1902. Thomas came to Butte from the city of Boyle in County Sligo, Ireland. Bridget emigrated from Clunnimny, Ballaghaderren, County Mayo, Ireland. Tom worked as a miner until partially blinded by an underground blast. The McGraths would operate boardinghouses at 127 West Woolman Street and 8 West Copper Street and raise four daughters. (Courtesy of Mary Lou Sweeney, Caryl Sullivan, and Bob Bennie.)

The life of a miner in Butte, Montana was not an easy one. In what were depicted as the most dangerous mines in the world, fatalities would strike Butte miners weekly from such things as falls of ground, hoisting accidents, blasting, and electrocutions. The "Speculator Mine Disaster" killed 168 men. Below, family members wait in torment to hear the fate of loved ones. (Courtesy of the World Museum of Mining.)

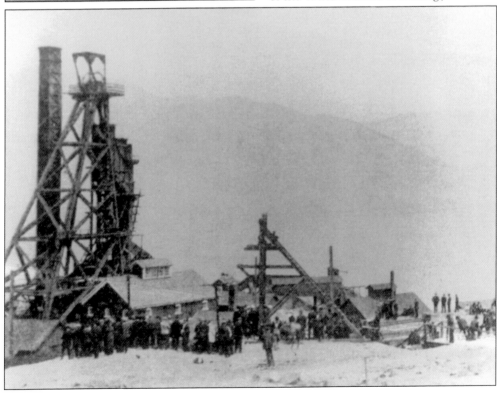

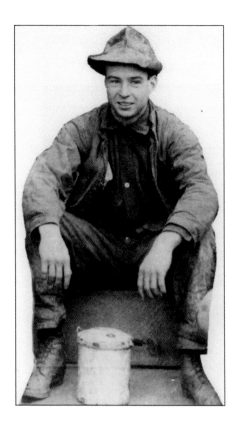

On June 15, 1917, the night of the "North Butte Mining Disaster," Manus Duggan was a young father-to-be. Leading 28 men to a blind drift at the 2,400 level, Duggan instructed the group to build a bulkhead of timber and dirt. As the hours passed and oxygen diminished, Manus wrote a loving note to his wife, then, in complete darkness, took three others to find a passage to save his charges. The four perished in the dark in search of safety, but those left in that drift lived to tell the heroic story. On June 18, 1917, Madge Brogan Duggan laid her husband's body to rest at St. Patrick's Cemetery. Three weeks after her husband's death, young Madge gave birth to daughter Manus Duggan. (Courtesy of Manus Farren.)

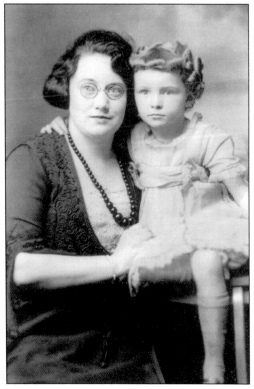

Nora Harrington was born in Ballinacarriga, County Cork, Ireland, in 1880. Immigrating to Butte, she met Jerry Holland, brother to her sister Mary's husband, Mike. Nora and Jerry were married and had three children—Aloysius, Lesley, and Evelyn. Jerry was killed at the Colusa mine on October 18, 1919. Like many young widows, Nora learned to be self-sufficient, opening a small store in her house on the corner of Montana and Pearl Streets. (Courtesy of Enda Healy Bowman.)

Helen and Ed Quinn pose with their father, Ed, in this photograph taken in 1923. On September 27, 1926, Ed perished from an accident at the Mountain Con mine. His young widow, Marian, would provide for her young children by making pasties and selling them to the miners for their lunch. Marian was well-known throughout Butte for her pasties and continued her business well into the 1950s. (Courtesy of Dan Shea and Maryanne Shea McVeigh.)

The Industrial Workers of the World, whose members were know as the "Wobblies," contend that all workers should be united as a class and that the wage system should be abolished. The IWW recruiting effort reached Butte in 1917 by way of union activist Frank Little, sent to organize the miners and lead a strike against the Anaconda Copper Company. Little was lynched in Butte on August 1, 1917, for his union and antiwar activities. (Courtesy of Debbie Bowman Shea.)

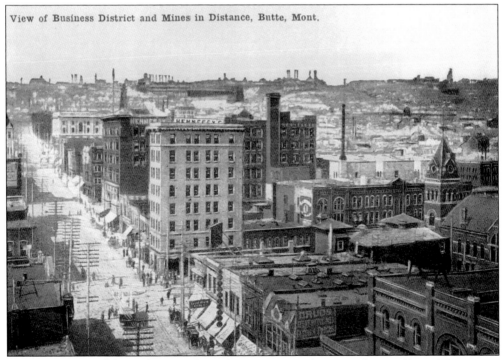

This 1920s postcard shows the Main Street business area, indicating a thriving Butte. The mining district is scattered across the skyline. (Courtesy of Ethel Foley Lyons.)

No. 4521 Butte, Montana, 8/1/19 191....

Metal Mine Workers' Union

GREETING: In consideration of the membership now held and enjoyed by Brother *Michael Healy* and it having been shown and desired by said brother that he seek work elsewhere and outside of the jurisdiction of the Butte Branch of the Metal Mine Workers' Union, we herewith grant this withdrawal card with the express understanding that the said brother shall deposit this card with the Secretary-Treasurer of this or any other Branch of the Metal Mine Workers' Union immediately upon receipt of employment in the Mining Industry now under the jurisdiction of the Metal Mine Workers' Union, or which may hereafter be established.

Michael Healy *Fred G. Clough*

Member's Signature. Secretary-Treasurer.

Known as the "Gibraltar of Unionism," Butte's labor union movement organized 34 unions by 1900 in order to counter the power of the Anaconda Company. These unions represented various trades within the "Mining City." The Butte Miners Union became Local No. 1 of the newly organized Western Federation of Mines. (Courtesy of Healy family.)

Bridget Shea was widowed during the influenza epidemic of 1918. Bridget raised four children working as a waitress. In 1930, she began a 25-year career as business agent for the Women's Protective Union. Founded in 1875 to promote the "dignity of women's labor," the Woman's Protective Union was the first women's trade union. (Courtesy of the Butte Silver Bow Archives.)

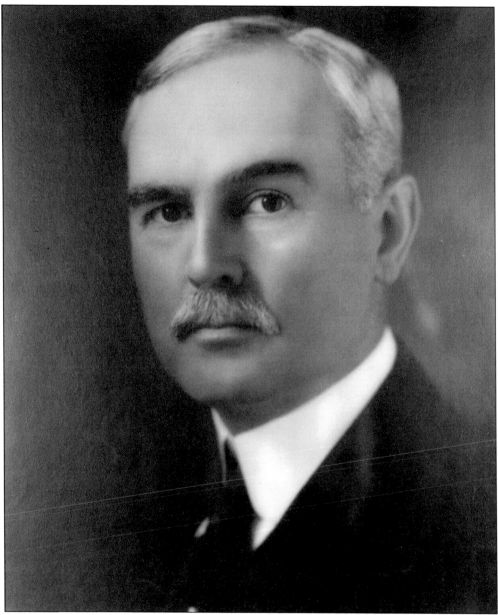

Marcus Daly died in 1900. His widow, Maggie Daly, befriended an Irish gentlemen by the name of John D. Ryan (pictured here) who, in 1901, acquired interest in the Daly Bank and Trust Company, located in Anaconda, Montana. Ryan would soon become its president and subsequently manager of Marcus Daly's fortune. Other notable Irish during this time were Cornelius Con Kelly, a lawyer who directed both the Anaconda Company and the Montana Power; William McDowall, who managed the office of the Anaconda Company for Marcus Daly and would later serve in the Montana legislature as speaker of the house, in state government as lieutenant governor, and finally U.S. ambassador to Ireland; and judge Jeremiah Lynch, born in County Cork, Ireland. Lynch would work as both a miner and bartender in the mining camp and later be elected to serve as district court judge. His most revered role was as an Irish community leader. (Courtesy of the World Museum of Mining.)

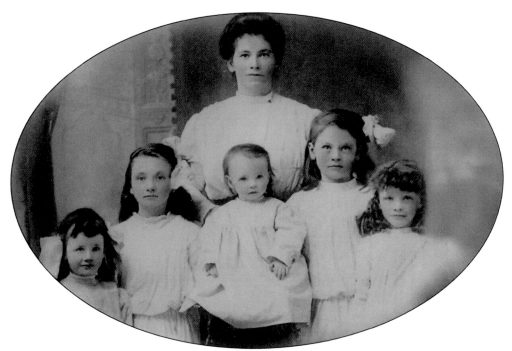

Kate Lynch O'Sullivan of Eyeries was a cousin to judge Jeremiah Lynch. She married Jeremiah O'Sullivan of Allihies. Kate and her daughters came to Butte in 1909 to join Jeremiah, who was already working there. The O'Sullivans' daughters are, from left to right, Nellie, Julia, Annie, Josephine, and Katherine. Their descendants still living in and around Butte are the Ann and Emmett Thornton family; Jim, Julie Nellie, Jeannie, Mike and Jerry Sullivan; Rogue Schonsberg; Jeri Nichols; Mary Joan Bickford; and the Tom, Susie, and Mary Beth McIntyre families. (Courtesy of Tracy Thornton.)

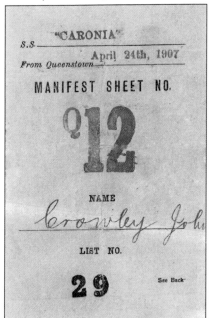

John Crowley left Queenstown, County Cork, Ireland, for America aboard the *Caronia* on April, 24, 1907. After the ship docked in Manhattan, steerage passengers were moved to a waiting area. Each passenger wore a name tag with his or her manifest number written in large letters. Immigrants were assembled in groups of 30 according to their manifest letters and transported on a barge to Ellis Island to await final inspection. (Courtesy of Julie Crowley.)

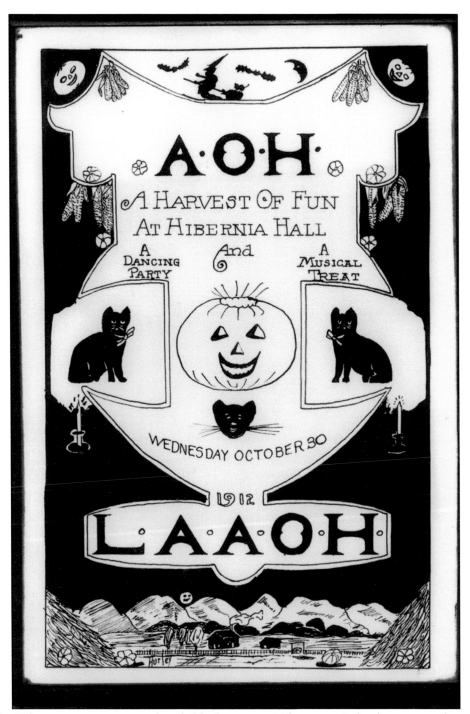

The Hibernian movement was founded by laymen in 16th-century Ireland to protect clergy of the Catholic faith from persecution by the English monarchy. In the United States, it was formed to aid newly arrived Irish both socially and economically while bridging generations with their ancestral homeland. The Butte AOH was active not only politically but also socially, as shown by this Halloween invitation. (Courtesy of J. D. Lynch.)

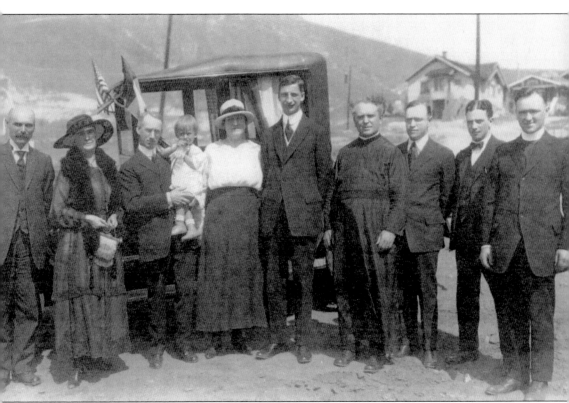

On a nationwide campaign to enlist support for a free and independent Ireland, political activist Eamon de Valera (later to be Ireland's third president) journeyed the many miles from Dublin to Butte raising money to secure support for the Irish Republic. Pictured here are Irish community leader judge Jeremiah J. Lynch, Mary A Rockwood, Dr. M. J. Scott (chief of surgery at St. James Hospital), Thomas Scott, Mary Agnes Rita Scott, Eamon de Valera, Rev. P. J. O'Reilly, Dr. J. C. Shields, Sean Nunan (secretary to President de Valera) and the Reverend Michael Leonard. (Courtesy of Michael J. Scott III collection, Seattle, Washington.)

On March 17, 1921, the Butte Irish hosted a reception for Ireland's Mary MacSwiney, whose brother Terence, the Lord Mayor of Cork, had recently died in an English prison as a result of a hunger strike. The invitation was sent to active members in the Ancient Order of Hibernians and the Robert Emmet Literary Association and raised significant capital to return to advance the cause of the Irish Free State and preservation of Irish culture. (Courtesy of Enda Healy Bowman.)

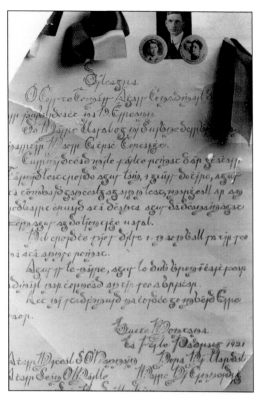

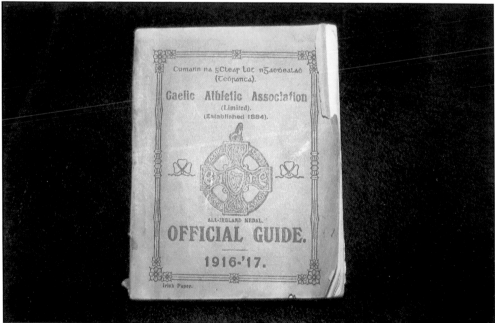

Irish games, particularly Irish football, were played informally and often disruptively in Butte until 1913, when the Gaelic Athletic Association was formed for the purpose of carrying on games in a peaceable manner. The Gaelic Athletic Association's official guide, both in Gaelic and English, was used to regulate the league. (Courtesy of Enda Healy Bowman.)

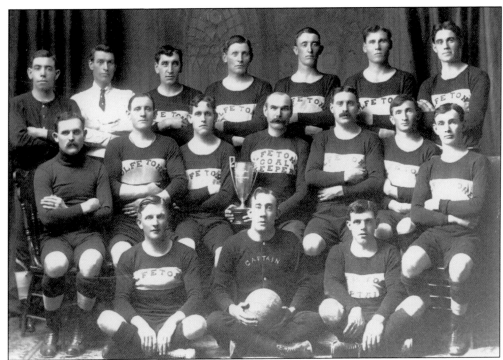

The 1911 Wolfe Tone Gaelic Football League team champions were the Montana Gaelic Athletic Association. They are, from left to right, (first row) Johnny (The Store) Murphy, John T. Sheehan (captain), and James Shields; (second row) John T. (Sherigg) Sullivan, Jeremiah Sheehan, Michael (Micky the Bird) Sullivan, Judge J. J. Lynch, John J. Sullivan, John (Pigeon) Shea, and John McCarthy; (third row) Dan Leahy, Maurice Sullivan, Con Shea, James McCarthy, Tim Lynch, Michael McCarthy, and Michael Healy. (Courtesy of Jack Sheehan, Minden, Nevada.)

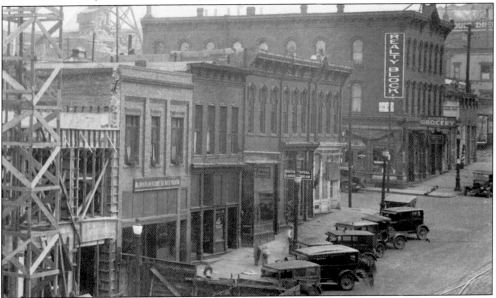

Taken in the early 1920s, this photograph shows construction on the 200 block of Main Street with the Original mine in the background. (Courtesy of Healy family.)

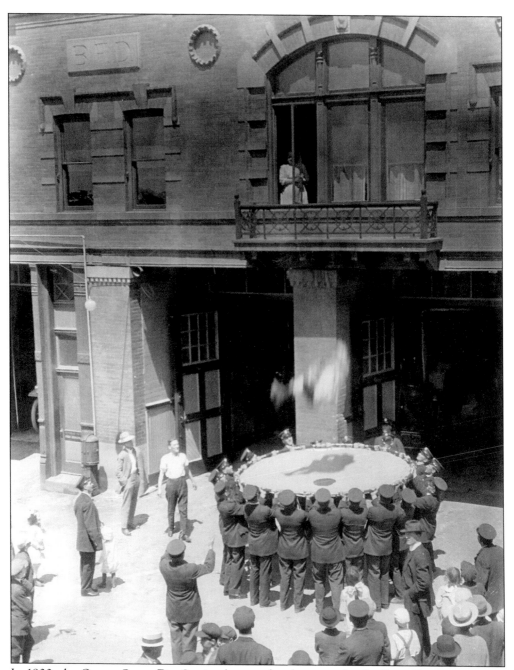

In 1900, the Quartz Street Fire Station became headquarters for the Butte Fire Department, serving in that capacity until 1976 when headquarters would move to the Montana Mercury Street Station, and the Quartz Street Station would become home to the Butte Silver Bow Archives. A roll call of firemen from 1883 to the present reads like an Irish city directory. Fire chiefs include McCarthy, O'Brien, Murray, Flannery, O'Donnell, McCarthy, and Leary. The longest tenure in the department, with 50-plus years, goes to Patrick Healey. Line of duty deaths include O'Connor, Gleason, Behan, Lynch, Nolan, Fleming, O'Brien, Sloan, and Deloughery. (Courtesy of the Butte Silver Bow Archives, Tim McCarthy, and John Paull.)

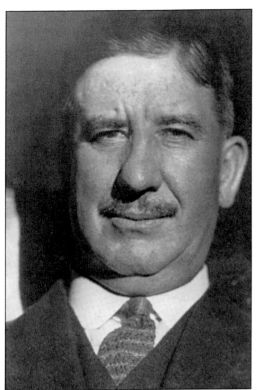

Born in Ireland, Butte's chief of police "Jere the Wise" Murphy was a 6-foot, 200-pound well-dressed gentleman whom it would have been unwise to challenge. Through the years, Butte's police force has been manned by many Irish, numerous to fall in the line of duty. (Courtesy of the Butte Silver Bow Archives.)

The John Shea family lived on the West Side at 1024 Waukesha Street. Pictured here are, from left to right, (first row) Margaret and Bridget; (second row) Dan, John, Margaret with baby Babba, Alice; (third row) Florence (Nin), Jack, Jim, Ed, Neil, and Emmett. (Courtesy of Carol Driscoll Brown and Shelly Hoar.)

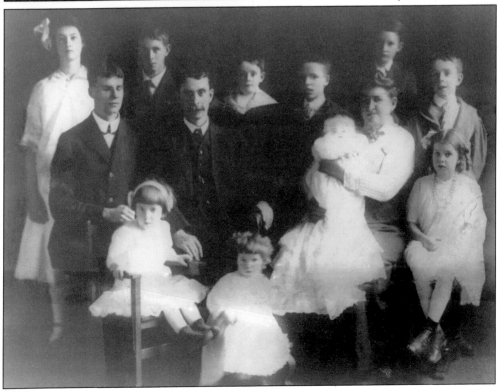

Michael "Black Mike" Murphy was born in 1864 in Allihies, County Cork, Ireland. He married Mary Ellen "Nellie" Sullivan in Butte before the beginning of the 20th century. They resided at 625 North Montana Street in the area known as Muckerville. In this photograph, taken around 1912, clockwise from center are Mary Ellen, young Mike, Michael, Margaret, Mildred, Frank and Kate. (Courtesy of Frank "Pete" Rosa.)

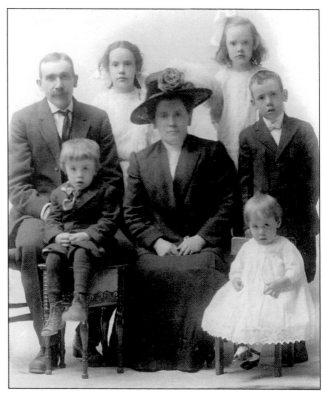

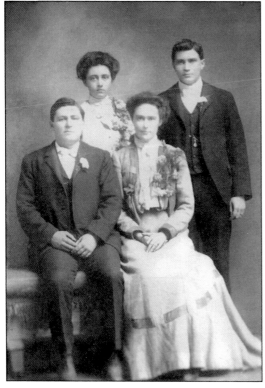

James Harrington (seated at left), also known as "Jim the Tadig," was brought as an infant from County Cork, Ireland, to Calumet, Michigan, and then to Butte. He married Minnie Sheehan and became a successful miner in Butte, staking a number of claims north of Walkerville, including the Alice and Gertrude, named after his daughters. (Courtesy of James Harrington.)

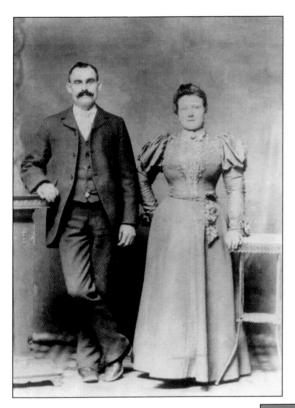

Eugene Sullivan and Johanna Sullivan immigrated separately in the late 19th century. Although both were from the Beara Peninsula in the west of County Cork, they first met in the United States. They were married in Butte in 1897. (Courtesy of Dianna Porter.)

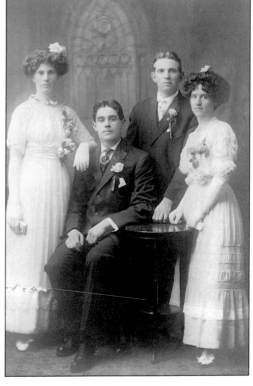

Michael Cornelius Healy—son of Cornelius Healy and Catherine O'Sullivan Healy of Eyeries Parish, County Cork, Ireland—and Abigail "Bina" Harrington—daughter of Tim Harrington and Ellen O'Sullivan Harrington of Allihies Parish, County Cork, Ireland—were wed at St. Mary's Church in Butte, Montana, on November 25, 1911, by the Reverend M. McCormick. Witnesses were best man and childhood friend John Crowley and maid of honor Abbie Holland. (Courtesy of Enda Healy Bowman.)

From left to right, Loretta, Bernard, and Joseph Harrington, children of Daniel and Johanna Harrington from County Cork, Ireland, were raised at 45 West Woolman Street. Daniel died young and Johanna worked as a housekeeper. Joseph would die of consumption in his early 20s from work in the mine. (Courtesy of Bernard Harrington family.)

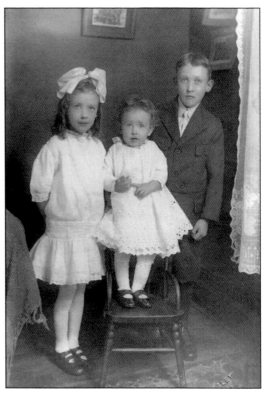

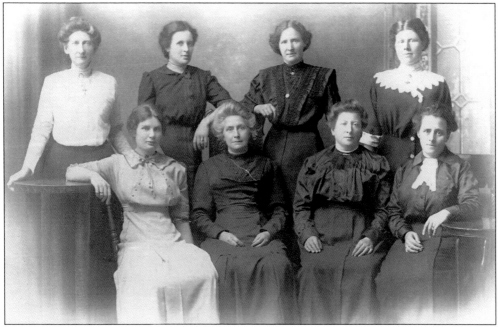

Posing for a family picture, these Irish belles gather to celebrate their heritage. From left to right are (seated) Kate Sweeney, Annie McGuire, Mrs. Waldron, and Mary (Mulholland) Barry; (standing) Ellen Byrne, Hane (Mulholland) Savage, Mary Jane Byrne, and Margaret "Maggie" Lyden. (Courtesy of Richard Barry family.)

Catherine Barry is pictured in this c. 1900 photograph. (Courtesy of Richard Barry family.)

Mr. and Mrs. John T. Sheehan, from County Cork, Ireland, are shown with their children Agnes and John. (Courtesy of Tracy Thornton.)

Tim Dwyer was born in August 1899 in Ardgroom, County Cork, Ireland. He fought in the Black and Tan Wars and was present for the Crossbarry Ambush in March 1921, one of the largest battles in the war for independence between the Irish Republican and British armies. In 1926, Tim came to Butte, Montana, and married Nellie Riley Dwyer. They had one daughter, Ann Dwyer Rosa, and three grandchildren—Paul, Catherine, and Margaret. (Courtesy of Fr. Gregory Burke and Ann Dwyer Rosa.)

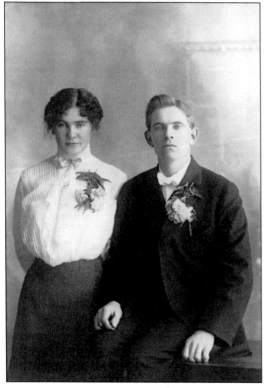

Julia Sullivan from County Kerry, Ireland, and John Daniel Crowley Sr. from County Cork, Ireland, married in Saint Mary's Church. They resided at 37 Anaconda Road and raising three sons there. (Courtesy of Julie Crowley,)

Michael McLaughlin came to Butte from Cardonagh, Ireland, in 1914 to work in the mines. Kate Leahy arrived in Butte in 1923 from the parish of Eyeries in County Cork, Ireland. Michael and Kate married and had six children—Sarah, Michael, Mary, Rita, William, and John. Michael worked hard as a hod carrier, and his three sons followed in the building trade as bricklayers. Cement work done at the Granite Mountain Memorial was done by son Jack and grandson Michael. (Courtesy of Rita McLaughlin Casagranda.)

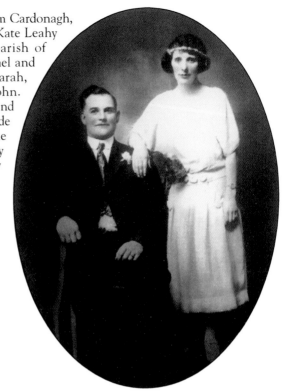

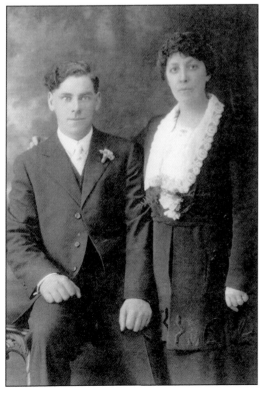

Daniel and Margaret O'Brien from County Cork, Ireland, are shown at left on their wedding day. They resided on Woolman Street throughout their married years. (Courtesy of Mike Paul.)

Ed and Marie Foley lived in Walkerville. Ed's parents emigrated from County Waterford, Ireland. Ed worked for the mines. Marie died in 1933 after giving birth to her fourth child, and so Marie's mother moved into Ed's home to help raise the four children—ages 6 years, 4 years, 18 months, and 9 days. (Courtesy of Ethel Foley Lyons.)

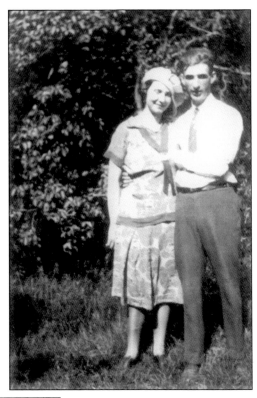

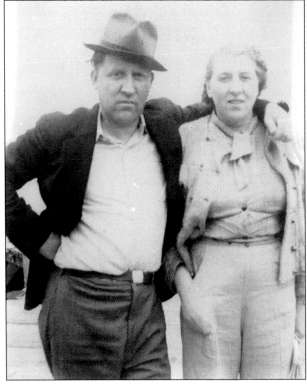

Timothy Sullivan and Agnes Cummins married in County Cork, Ireland, in the 1920s. Tim moved to Butte and joined Agnes's sister Bee and her husband. Agnes and baby Mary Jo would move to Butte soon after. Daughters Patsy and Aggie were born in Butte as was cousin Catherine, daughter of Bee and Pat Harrington, who owned the Shillelaghe Bar in the 5-mile area of Butte. (Courtesy of Aggie Sullivan Metz)

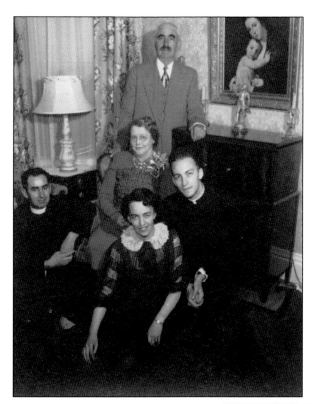

Sean O Sullivan came to Butte from Inish Fornard, County Cork, Ireland, and his wife, Josephine Murphy O Sullivan, emigrated from Caherceem, County Cork, Ireland. They are pictured at left with son Fr. Eamon de Velera O Sullivan (far left), daughter Veronica O Sullivan, and son Fr. Sarsfield O Sullivan. The O Sullivan family was politically active in assisting to secure an Irish Free State, as were many Butte Irish. (Courtesy of the O Sullivan estate.)

Sophie Boyle left Londonderry, Ireland, on the vessel *Caledonia* in October 1911. Arriving in Butte, she resided at 503 West Woolman Street. Sophie signed her Declaration of Intention to become a U.S. citizen on February 19, 1926. In the document, she denounces allegiance to George V, King of Great Britain and Ireland, and confirmed she was not an anarchist or a polygamist nor a believer in the practice of polygamy. (Courtesy of Jim Lyons family.)

Ed Foley (with cigarette far right) and crew are shown down in a mine in the 1920s. (Courtesy of Ethel Foley Lyons.)

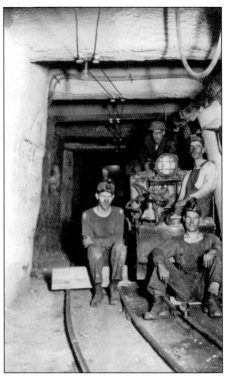

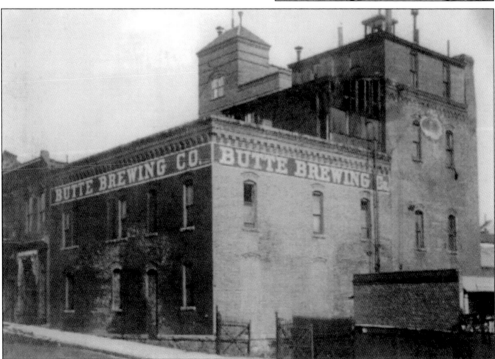

The Butte Brewery was established in 1885 on Wyoming Street between Granite and Quartz Streets. All materials used in the making of the Butte Brewery's beer come from Montana. (Courtesy of Butte Silver Bow Archives.)

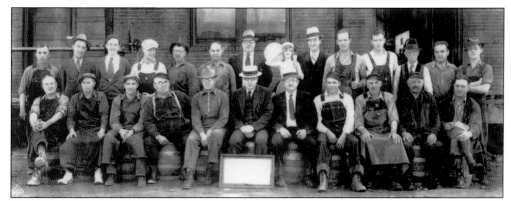

The Butte Brewery employed a great many Irishmen. This picture taken in 1936 includes McCarthys, O'Briens, Sullivans, and Keefes. Owner Tom Kelly is seated in the middle of the first row. (Courtesy of Lynn Keefe Guay.)

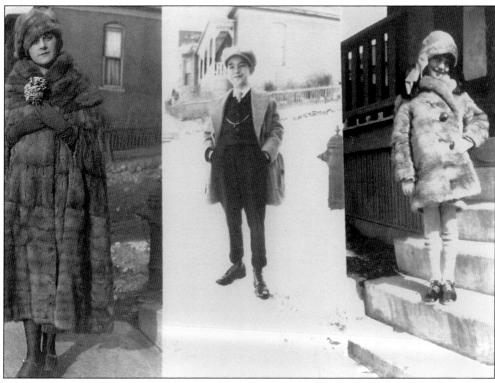

Mildred, Bob, and LeeAnn Evans, part of the "Fur-Bearing Harringtons," pose for this picture in the late 1920s. The name "Fur-Bearing Harringtons" was given when Mildred's mother Julia Harrington, who was a marvelous seamstress, made dresses with little fur collars for all of her eight little girls, which they proudly wore to Sunday Mass. (Courtesy of Monica Evans Cavanaugh.)

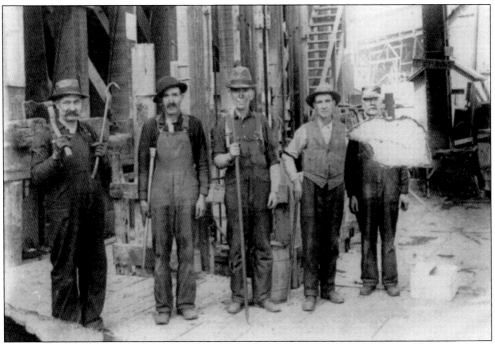

This photograph, taken at the Original Mine prior to World War I, shows "Black Mike" Murphy (second from left) and fellow crewmen before going underground for their shift. (Courtesy of Frank "Pete" Rosa.)

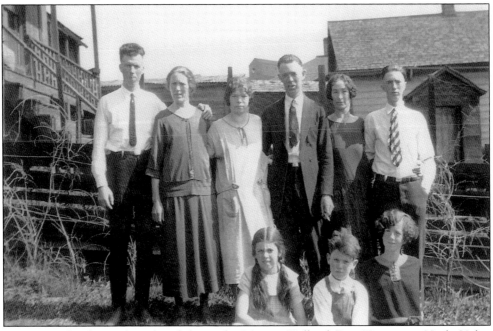

Harrington family members, from left to right, Maurice Holland, Bina Harrington Healy, Helen Lowney, Tim Harrington, Nora Harrington Holland, Lou Holland, Vonie Healy, Emmet Healy, and Evie Holland stop for a family picture in the back of Nora Harrington Holland's house on Pearl Street in the early 1920s. (Courtesy of Enda Healy Bowman.)

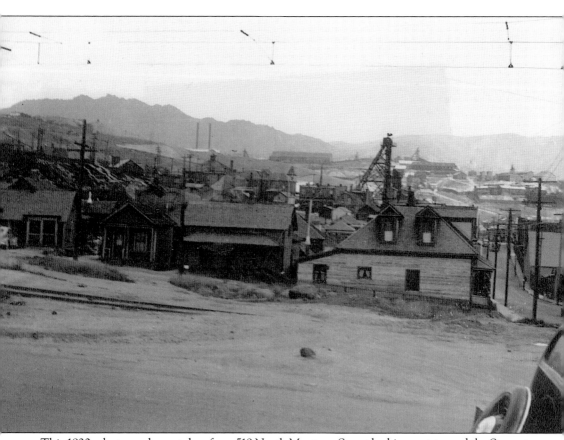

This 1920s photograph was taken from 519 North Montana Street looking east toward the Stewart Mine. (Courtesy of Cherie Bowman Lyons.)

Two

Neartú na h-Oidhreachta
Building the Legacy

The decades that would follow the large influx of Irish immigrants to Butte around 1900 gave way to political, social, and economic change, and the Irish were in the mix of it. What kept the Irish in Butte through years of mining strikes and political unrest was what they sewed into the fabric of the Butte community. It was Irish neighborhoods like Dublin Gulch, Corktown, Walkerville, Sunnyside, Centerville, and Muckerville nurturing and preserving the indomitable Irish family. It was the Irish in mining, reveling in its glory yet succumbing to the sorrows that left families shattered. It was the Irish in organized labor, fighting the good fight for good wages and safe working conditions. It included fraternal organizations like the Ancient Order of Hibernians (AOH) and the Robert Emmet Literary Association (RELA), binding in ethnic solidarity the upper class with the mining muckers to advance the cause of Ireland as a free nation. There was the Roman Catholic Church, the center of the Irish community, taking care of the spiritual, educational, political, and social needs of its parishioners. Irish infiltrated every surface of Butte politics, aligning early on with the Democratic Party. Finally it was the resilience of a clan who left their homeland to secure a better life, a people who knew adversity, struggle, and sorrow, yet celebrated life at every opportunity.

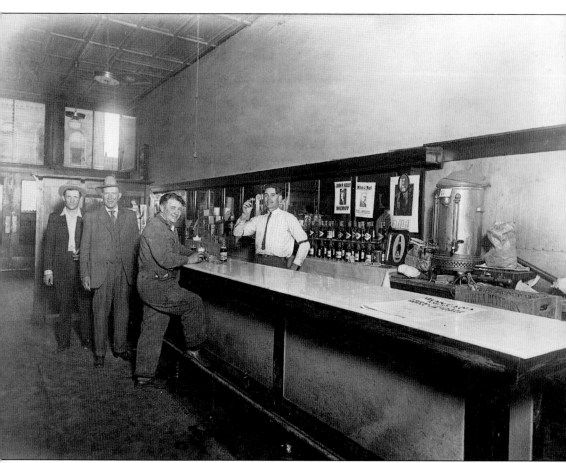

Michael Healy immigrated to Butte, Montana, from Ardgroom, County Cork, Ireland, in 1907. After working in the mines and grocery business, he purchased the Radio Bar at 219 (shown above) and 219 ½ North Main Street. Like many during Prohibition, Mike became a bootlegger and had stills in the 9-mile area. When the Radio Bar at 219 was abated for the selling of alcohol, Mike would move the establishment to 219 ½. The dark oak, beautifully detailed back bar at 219 ½ North Main (not shown here) survived the years of Prohibition and was sold by Mike to Les Stiles of Virginia City, Montana, for $1. It is now the focal point of the Pioneer Bar in the historical mining camp of Virginia City. (Courtesy of Healy family.)

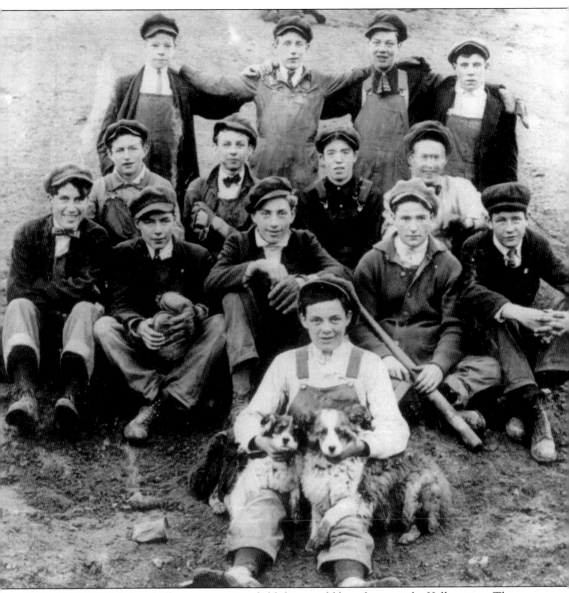

The Dublin Gulch baseball team poses in a field that would later become the Kelley mine. These young athletes challenged any team in the district their age, claiming many league titles through the years. Shown from left to right are (first row) Dan "Coney" Cohan; (second row) Tim "Tige" Connelly (later to become a great handball player), Frank "Fatty Connelly, Tim "Harp" Murphy, James "Gravel" O'Leary, and Joe Corcorhan; (third row) Joe "Baker" Sullivan, Dan "Dunne" Harrington, John "Buck" Kelly, and Pat Connelly; (fourth row) John "Turk" Murphy, John "Scottie" Dooris, Jerry Cohan, and Steve Sullivan (who in later years would letter in four sports at the University of Montana). Absent from the picture were pitcher Pat Kane and first baseman Joe Kane, later known as Dr. Pat Kane and Dr. Joe Kane. (Courtesy of Tom Kelly.)

Lizzie Hagan Keough arrived in Butte with her father, Jim Hagan, in May 1905. As her mother was sending her child and husband off from the docks of Liverpool, she told her daughter in a loving voice, "Now don't forget, Lizzie. When you get to the New World, don't stop in America. Go straight to Butte, Montana." Lizzie would never see her mother again. Lizzie was grandmother to Robert "Evel" Knievel, Nic Knievel, Sister Tony Harris, Patty Lisac, Jack Kraft, and Congressman Pat Williams. (Courtesy of Pat Williams.)

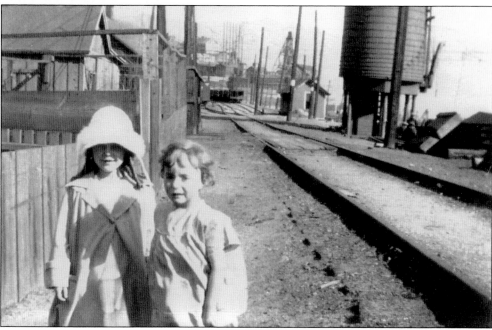

This picture, taken by John Shannon, road master for the Butte, Anaconda, and Pacific Railroad (BA&P), is of his daughter Marian Shannon (right) and her friend Patricia McCauley at 104 1/2 Bell Street, looking east toward Wyoming. The infamous Overall Gang, noted for robbing the Anaconda Company and the trains as they passed by, can be seen under the water tank just at the end of the Shannons' fence. The water tank provided water for the BA&P steam engine's 8-mile uphill journey to the Anaconda mine in the early days of mining. (Courtesy of Kevin Shannon.)

Kate Sullivan Riley and James Daniel
Riley are pictured in their backyard
at 829 West Copper Street in Butte.
(Courtesy of Ann Dwyer Rosa.)

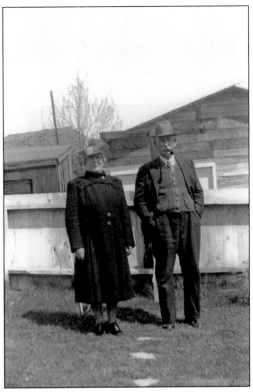

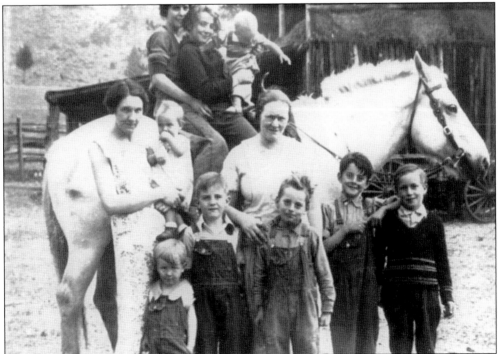

Honore Shannon (center) is pictured with her children, nieces, and nephews at the Shannon
ranch in Brown's Gulch in this early-1930s picture. (Courtesy of Kevin Shannon.)

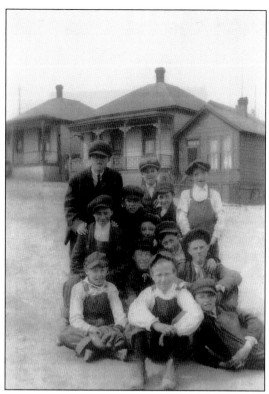

This photograph, taken the early 1920s, captures the spirit of the Irish youth. These Corktown youth were known as "The Owls." (Courtesy of Tom Mulcahy.)

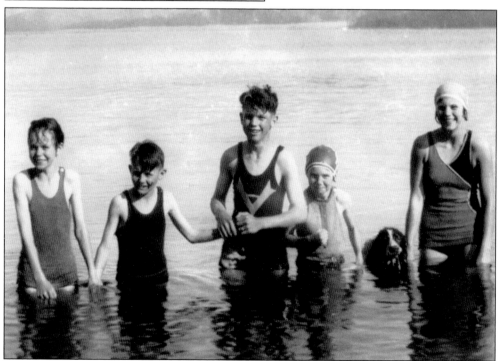

From left to right, Vivian Healy, John Cummings, Emmet Healy, Enda Healy and Vonie Healy swimming at Holland Lake in the late 1920s. (Courtesy of Healy family.)

John Daniel Crowley from County Cork, Ireland, and Julia Sullivan Crowley from County Kerry, Ireland, had three sons. The Crowley brothers—from left to right, Daniel Raymond "Ray," Timothy "Leo," and John Joseph "Jack"—lived on Anaconda Road. (Courtesy of Julie Crowley.)

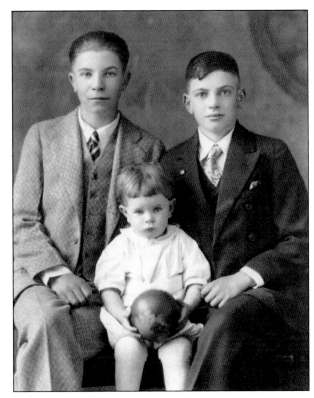

Catherine Hanley Shields was one of 11 children born in Butte to John and Margaret Hanley. She was a nurse at St. James Hospital in Butte when she met and married Dr. James C. Shields, who practiced surgery in Butte for over 50 years. Among their children were James Shields, Ph.D., who, at 30 years, became the youngest president ever of the university system in Mexico; John Shields, M.D., who became chief of the Radiology Department at St. Louis University; and Anne Jane Shields Staples (pictured at left with her mother, Catherine), who graduated from Marquette and Columbia Universities and married Dr. Daniel Staples. (Courtesy of World Museum of Mining and Mark Staples.)

45

William and Catherine Maher, born in Tipperary, Ireland, came to Butte around 1900 to work in the mines and raise their four children in Dublin Gulch. (Courtesy of Judy Garlish Jonart.)

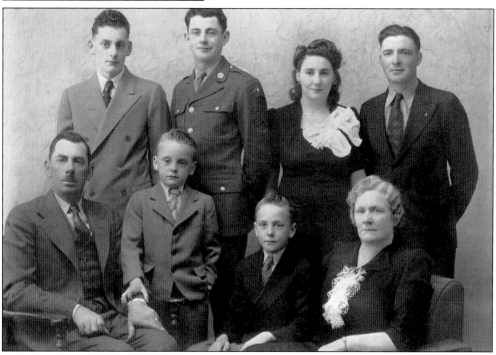

The Shannon family portrait was taken during World War II, when Kevin Shannon was home on leave. In this photograph are, from left to right, (first row) John Shannon, Jerome Shannon, Vince Shannon, and Honora Shannon; (second row) Joe Shannon, Kevin Shannon, Marian (Shannon) Lorello, and Joe Lorello. (Courtesy of Shannon family.)

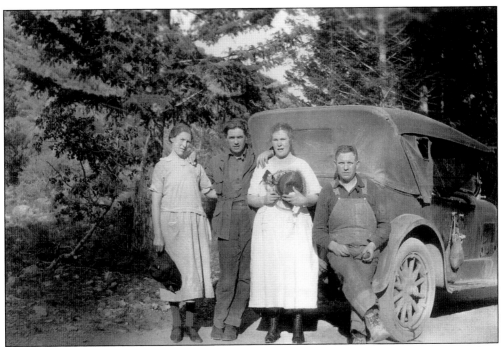

From left to right, Michael and Bina Healy and Julia and Jack Crowley enjoy a day away from their work in Butte fishing at Maiden Rock on the Big Hole River. (Courtesy of Healy family.)

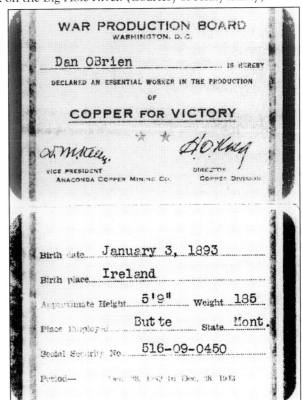

Dan O'Brien was given this card to continue his work in the mine on behalf of the war effort. (Courtesy of Mike Paul.)

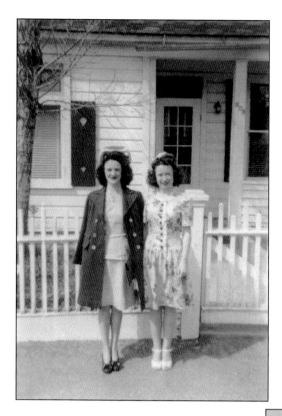

Audrey Gerry (left) and cousin Helen Gerry, daughter of Ed Gerry and Ethel O'Leary Gerry, are in front of the Gerry family home on Woolman Street. (Courtesy of Bermingham family.)

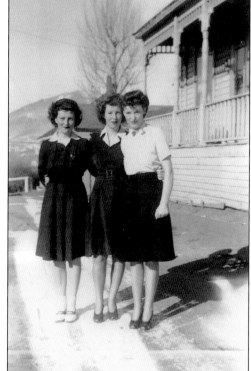

Pictured ready to go out on the town are, from left to right, Charlotte, Mary, and Rita McGee in front of their house on Virginia Street in the early 1940s. (Courtesy of Rita McGee.)

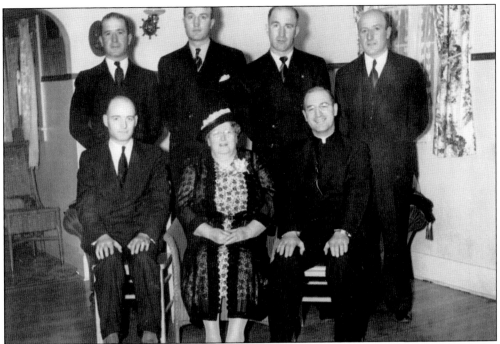

This McCarthy family gathering photograph includes, from left to right, (first row) John McCarthy; Johanna Cumba McCarthy, who emigrated from Gorthaig Allihies, County Cork, Ireland, in 1885 and married Dan McCarthy Sr.; and Fr. Charles McCarthy; (second row) Dan McCarthy, Jim McCarthy, Pat McCarthy, and Tim McCarthy. Missing from the picture are daughters Josephine and Theresa. (Courtesy of Tim, Dan, and Jim McCarthy.)

The Maher family is celebrating the Fourth of July in this 1940 photograph. Pictured are, from left to right, (first row) Patsy and Eddy Maher; (second row) Shirley and Joe Maher; (third row) William and Ed Maher. (Courtesy of Judy Garlish Jonart.)

Gay Loggins O'Leary (first row right), daughter of Tom Loggins and Clarice (Harrington) Loggins, is shown celebrating a neighbor's birthday party on North Montana Street in 1940. (Courtesy of Mary O'Leary Fleming.)

The Kelly family reunion brought together children of John J. and Margaret Kelly from Berehaven, County Cork, Ireland. Pictured here are, from left to right, (first row) Michael, Margaret, Mayme, Frances "Red Neck," and Dan; (second row) William, John, Tim, and Tom. (Courtesy of Tom Kelly.)

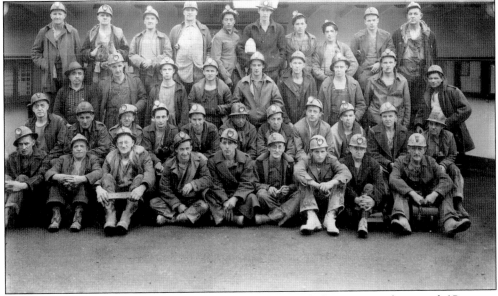

Taken in the mid-1950s, this picture shows a shift of miners before going underground. (Courtesy of Betty McNabb.)

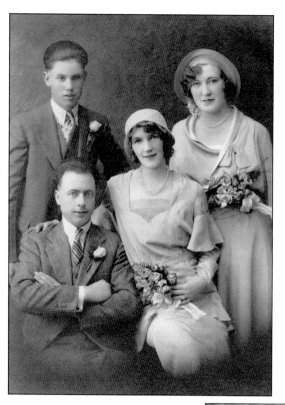

Jeremiah Ed Holland, son of Mike and Mary Holland of County Cork, married Mary Johnson, daughter of Mary Ann (Shea) and Tom Johnson, on April 26, 1931. Pictured seated are the bride and groom Ed and Mary with attendants Emmet Healy and Helen Johnson. (Courtesy of Colleen Lavelle.)

The married couple shown at right, Ed Moriarty—son of John and Kate (Sullivan) Moriarty—and Helen "Hellie" Moriarty—daughter of Patrick and Mary Ann (Doherty) McGonigle—raised their children Ed, Mary Kay, Bill, and Dan in Dublin Gulch. Daughter Mary Kay (Moriarty) Downey remembers the sounds of the mine whistles informing them they had to be some place, usually school, home, or church. "The buzzer on the Kelley Mine head frame, our next door neighbor, constantly called the mine cage up and down the deep shaft delivering miners or ore." (Courtesy of Dan Moriarty.)

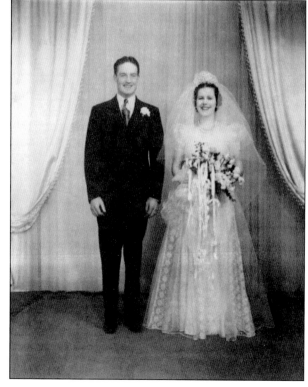

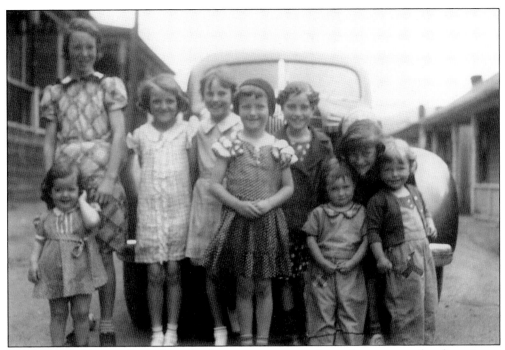

A shivaree on Virginia Street brought these youngsters together to bang pots and make noise on the occasion of the Shovlin family wedding. The noise would continue until the bride and groom came out and threw coins to the cheerful but noisy group. (Courtesy of Rita Melvin.)

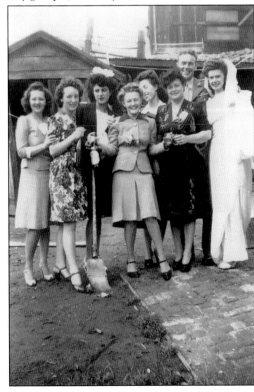

Mary Ellen O'Gara—daughter of Frances (Dougherty) O'Gara from County Mayo and Patrick O'Gara from Donegal—and John McGowan (shown at far right) celebrate at the home of the bride off of Wyoming Street after their nuptials, which were performed at St. Mary's Church. (Courtesy of Rita Melvin.)

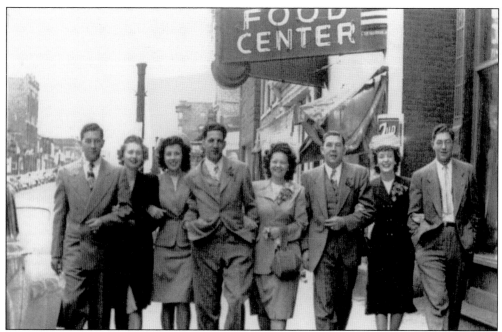

September 9, 1947, was a great day for the Irish when Helen O'Brien married Tom Paul at a nuptial mass in St. Mary's Church in Butte. The war was over; the town was booming, and life held great promise for this handsome wedding party. Pictured from left to right are Bernard O'Brien, Edna O'Brien, Irene Kelly, groom Tom Paul, bride Helen O'Brien Paul, best man Terry Kelly, maid of honor Rita McGee, and Ed O'Brien. (Courtesy of the O'Brien/Paul family.)

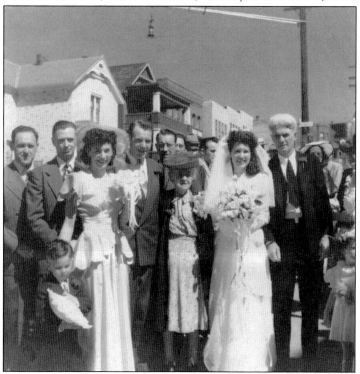

Enda Healy married Richard Bowman on July 12, 1947, Orangeman's Day. To redeem their questionable choice of date, their first daughter, Bonnie Patricia, was born on March 17, 1949. Posing for this wedding picture are, from left to right, Bernie Harrington, Fred McFaddan, Vonie O'Brien, Richard Bowman, Jack "Binty" O'Brien, Helen Bowman, Enda Healy Bowman, and Mike Healy. (Courtesy of Debbie Bowman Shea.)

Mary Patricia McBride—a descendant of the McBrides, Sullivans, and Duggans from Castletown, County Cork, and Donegal—and Robert Joseph Schulte—a descendant of the Mountains and Lundregans of Ireland—were wed February 5, 1949, at St. Lawrence O'Toole Church. The couple had seven children— Mike, Pat, Mark, Barb, Steve, Joe, and Mary Kay. All were raised in Butte with a loving Irish Catholic heritage. (Courtesy of Mike Schulte and Mary Kay Schulte Erickson.)

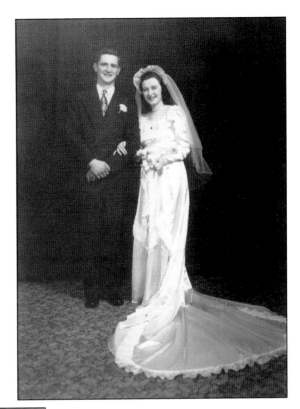

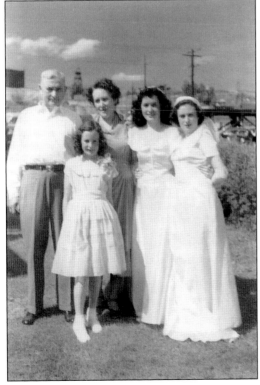

Patricia Shea Markovich wed William Markovich on July 15, 1950. Pictured at left is the Shea family before the nuptials. From left to right are Dan Shea (from Eyeries Parish, in County Cork) and Peg Lowney Shea (from Castletown, Berehaven, County Cork) and their daughters Donna Shea (Thompson), bride Patricia Shea Markovich, and Maureen Shea (Yelenich) in the backyard of their home on East Woolman Street. (Courtesy of Maureen Yelenich.)

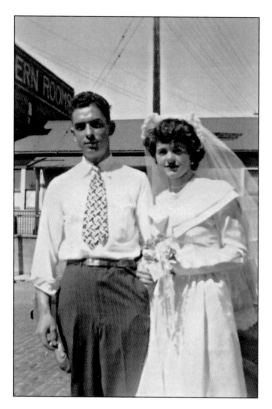

Helen Holland, daughter of Ed and Mary Holland, married Bill Lavelle in St. Mary's Church and took residence on North Montana Street. They had three daughters—Colleen, Vonnie, and Kelli. (Courtesy of Colleen Lavelle.)

Rose Sullivan Shovlin was widowed at a young age and raised her six children—Ann, Frank, Dan, twins Mary and Kate, and Bill—as a single mother. Rose lived at 414 Virginia Street. (Courtesy of Rita Melvin.)

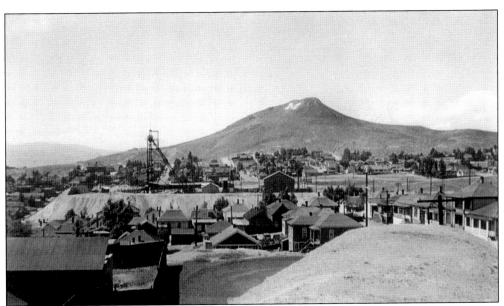

This 1940s picture was taken from the 200 block on West Woolman Street facing west and overlooking the Virginia Street rink and, in the distance, the Anselmo Mine. (Courtesy of Healy family.)

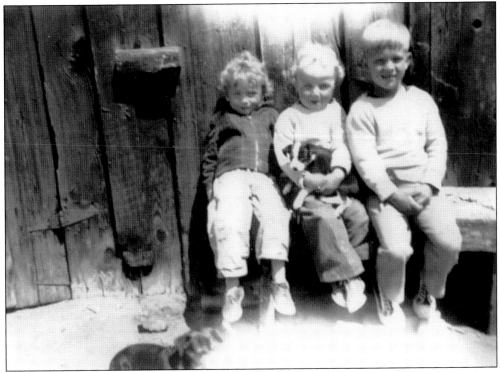

On July 4, 1947, from left to right, Joey Sullivan, Danette Harrington, and Lynn Leathers pause from a Fourth of July celebration to pose for a picture in Dublin Gulch. (Courtesy of Danette Harrington.)

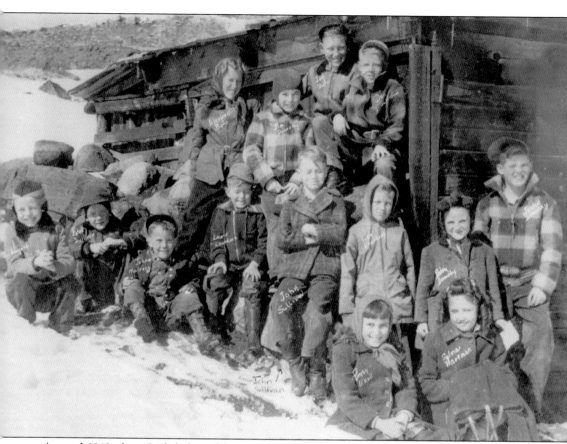

Around 1949, these Irish lads and lassies take a break from winter sledding to pose in front of Skuck Shea's shed in Dublin Gulch. Flashing Irish smiles for the camera are, from left to right, (first row) Peggy O'Neill and Sylvia Hartman; (second row) Jack Hogart, Red Sullivan, John Maloney, Louie Leathers, John Sullivan, Lynn Leathers, Patsy Dennehy, and Jackie Dennehy; (third row) Marlene Bato, Jim Dennehy, Joe Bato, and Dan Sullivan. (Courtesy Danette Harrington.)

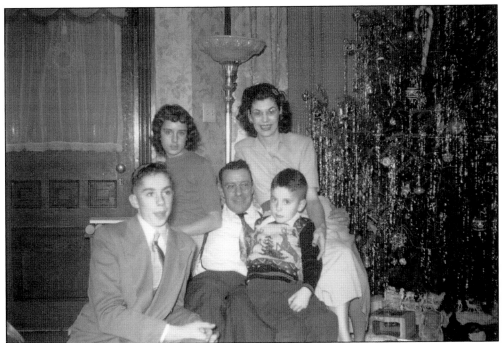

The John O'Brien family celebrates Christmas in 1949. Pictured are John "Binty" O'Brien, who worked as a foreman at the Butte Brewery, and Vonie Healy O'Brien with their children, from left to right, Dan, Arlene, and Mick. (Courtesy of Jack O'Brien.)

Duni Harrington is shown with grandchildren Kellie (left) and Danny in front of their barn at 317 Summit Street in Dublin Gulch in 1968. (Courtesy of Danette Harrington.)

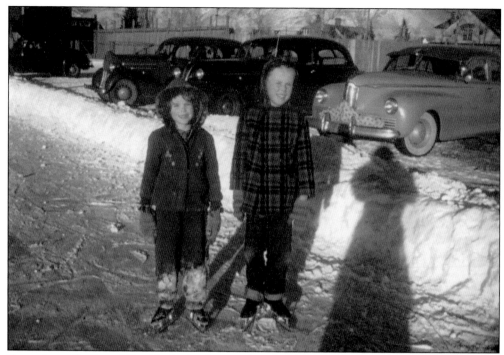

Young Lynn Keefe and Tim Keefe, daughter and son of Joe and Vivian (Healy) Keefe, enjoy a day of ice-skating at Clark's Park in the early 1950s. (Courtesy of Healy family.)

Cornelius "Con" O'Neill, a 37-year-old foreman of the Bell and Diamond mines that adjoined the Speculator mine, died heroically the night of the "Butte Mining Disaster" of 1917. Like fellow Irishmen J. D. Moore and Manus Dugan, his sacrifice was to secure the safety of his men. Con left behind his wife, Julia, and four small children. Pictured above from left to right is his family: Francis "Chick" O'Neill, Catherine O'Neill Dillion, Julia O'Neill, Lillian O'Neill Wolahan, and Alice O'Neill La Palm. (Courtesy of Julie Wolahan Thompson.)

From left to right, brothers Don and Ed Shea pose with friend and neighbor Vic O'Leary in front of their home at 107 Ruby street in the late 1940's. (Courtesy of Mary Kay Shea Hoy.)

Tom - Dorothy Joyce
Jack Prothero
Bill - Ester Bermingham
Jack Ester Cote
Ed - Mary Picard
Richard - Edna Bowman
Tom - Pat Kiley
Nick - Virginia Cladis
Helen - Dave Fisher
Brought - Ione McCarthy
Tom - Elaine McGree

Farewell
Party for Harp and Ester Cote
Teddy's. Jan 1958

Smither
Bul

This lifelong group of Irish friends grew up in various neighborhoods throughout Butte but gathered at the Catholic Youth Organization. Their friendship endured throughout their lifetimes. The occasion of this picture taken in January 1958 at the Rocky Mountain Café was a farewell dinner for Harp and Esther Cote, who would return to Butte in the late 1960s. Together this group had over 80 children, the majority of whom were raised in Butte and stayed to bring up yet another generation. Ann McCarthy Ueland claims to be in this picture with her mother, Ione McCarthy. (Courtesy of Ann McCarthy Ueland.)

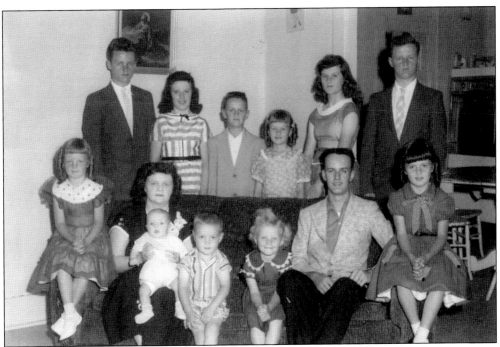

Alice Coles Downey raised 12 children after her husband died in 1957 at age 40. Alice was a janitorial worker for the Anaconda Company, one of five jobs she held to keep the home fires burning. Pictured here are Alice with children Pat, Tom, Jerry, Loretta, Mary, Tim, Alice, Deanie, Theresa, Rosie, Mark, and Mike at their home on the corner of Montana Street and Missoula Avenue. (Courtesy of Brendan McDonough.)

Joe Sheehy—son of Con Sheehy from County Kerry and Ann Sheehy from Castletownbera—and Francis Boyle Sheehy—daughter of Frank and Agnes Boyle from Northern Ireland—raised their seven children in Joe's family home at 621 North Montana Street in Muckerville. Pictured from left to right are (seated) Frank, Fran, Joe, Kathy, and Connie; (standing) Mike, Mary Jo, Marlene, and Jim. (Courtesy of Kathy Sheehy Lovell.)

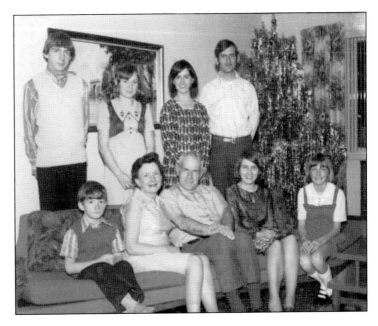

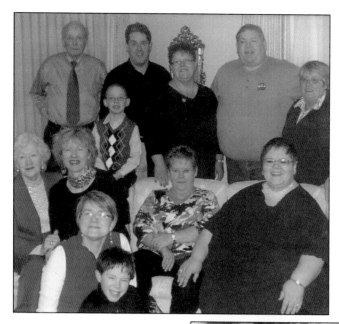

The Maloney and Lavelle families became one when Steve met Celine Lavelle, from County Kerry, in San Francisco. Family is everything to the Maloneys, children of Babe and Mary D. Anderson Maloney, and this happy clan is proof of that. Pictured from left to right are (first row) Linda Lavelle and Sam Maloney; (second row) Pat Lavelle, Celine (Lavelle) Maloney, Jack Maloney, Lori Maloney, and Kathy Maloney; (third row) Des Lavelle, Steve Maloney, Sherrie Maloney, Bill "Bubba" Maloney, and Mary Kay (Thompson) Maloney. (Courtesy of Steve Maloney.)

Born June 2, 1957, William "Bubba" Maloney almost immediately stole Butte's heart. Larger than life, he served as recording secretary for the Ancient Order of Hibernians, president of the Friendly Sons and Daughters of St. Patrick, and was a third-degree Knight of Columbus. He was a much sought after master of ceremonies, as his Irish sense of humor was matchless. Known throughout Montana, Bubba served as Butte's unofficial ambassador. In a tribute in the *Montana Standard* after his death on November 11, 2010, Tom Darragh said of his longtime friend, "As big as he was, his heart was even bigger." (Courtesy of Lori Maloney.)

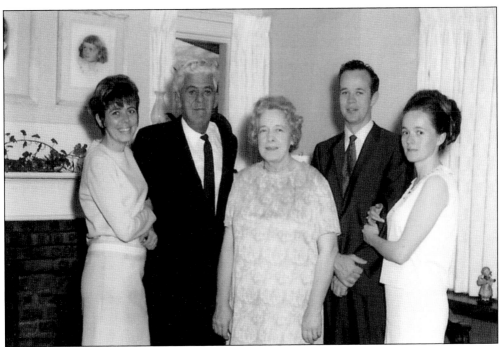

Robert McDonough was an independent businessman and owned R. E. McDonough Company. He and his wife, Mary, lived at 1911 Argyle Street with children, from left to right, Mary Margaret McDonough Gudoni, Bob McDonough, and Fran McDonough (later to be Fran Doran). (Courtesy of Brendan McDonough.)

Lifelong Butte residents Betty Ann Anderson Harrington and Bernie Harrington—son of Johannah and Daniel Harrington from County Cork, Ireland—are shown with their family in this image taken in the early 1960s. In the photograph are, from left to right, (first row) Bernie and Shaun; (second row) Joanne (Harrington) Nobil, Betty Ann Harrington, and Annie Anderson; (third row) Brian, Bernie, and Gary Harrington. (Courtesy of Meg Lambert Harrington.)

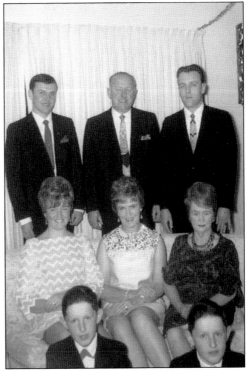

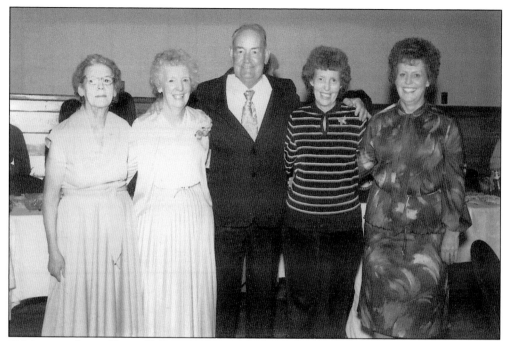

Celebrating the wedding of Margie Melvin and John Mansanti in September 1981 are, from left to right, Margaret McGee Lynch, Rita McGee Melvin, John McGee, Mary McGee Cummings, and Charlotte McGee Shields. The McGee siblings are the children of Charles and Margaret McCloskey Shields from County Donegal, Ireland. (Courtesy of Rita McGee Melvin.)

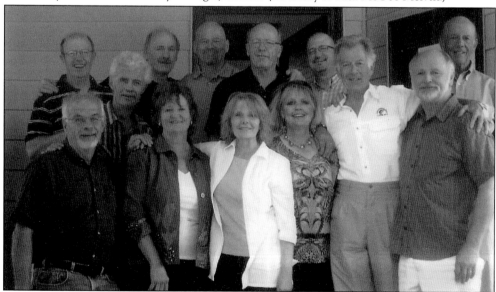

Red Robins (Costellos from County Mayo) and Mary Conolle Robins (Conolles from County Clair) raised their brood of 12 plus two Conolle nephews on Oregon Avenue. All of their children attended St. John's grade school and Butte Central. After years away, this close-knit family bought back their family home on Oregon Avenue as headquarters to gather. Brothers Bert and Mike then started a branch of their Sea Cast Company in Butte "to invest in this community we call home." (Picture courtesy of Robins family.)

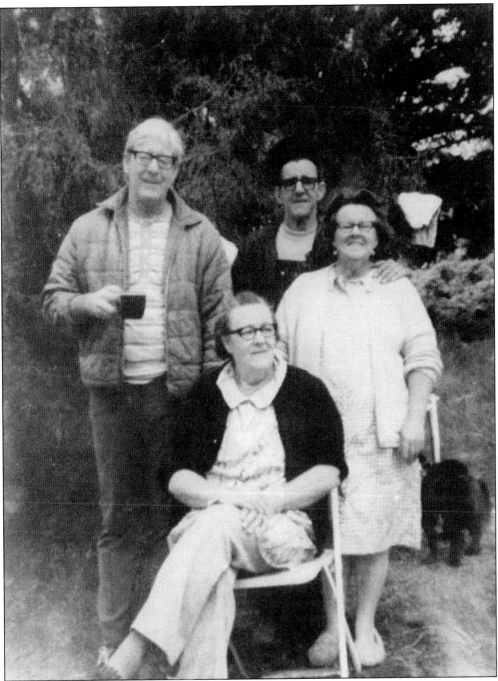

Charles Daly was born in 1884 in New Jersey. He came to Butte to mine and met Veronica Powers Daly, born in 1889. They married and settled in at 7 West Woolman Street. Pictured standing from left to right are their children Charles "Rip" Daly, Lawrence "Spike" Daly, Betty Daly Berg, and sitting is Jenny Daly Satterthwaite. Missing from the picture are brothers Sam Daly and Christian brother Mark Daly. (Courtesy of Mark Berg.)

From left to right, Ed Kelly poses with dog Dusty, young cousin Dan Kelly, and John Thatcher at the Kelly home at 17 West Woolman Street. Both Ed and John would excel in sports both at Boy's Central High School and in college. Through the years, Butte High coach John Thatcher would meet Butte Central coach Brodie Kelly (son of Ed and Shauna Lavelle Kelly) in the annual crosstown rivalry basketball game. (Courtesy of John Thatcher.)

Celebrating St. Patrick's Day on March 17, 1962, outside the Original Mine fence are, from left to right, Debbie Bowman, Pat Sheehan, Diane Hoar, Bonnie Bowman, Jenny Olson, Fran Daly, Mick O'Neill, and Jean Tritica. (Courtesy of Bonnie Bowman McGowan.)

In May 1962, these eighth-grade graduates of St. Mary's pose at the eighth-grade picnic at Gregson Hot Springs. Pictured from top to bottom are Judy Shea, Kay Shea, Coleen Barry, Kay Hastings, and Jodi Mee. (Courtesy of Bonnie Bowman McGowan.)

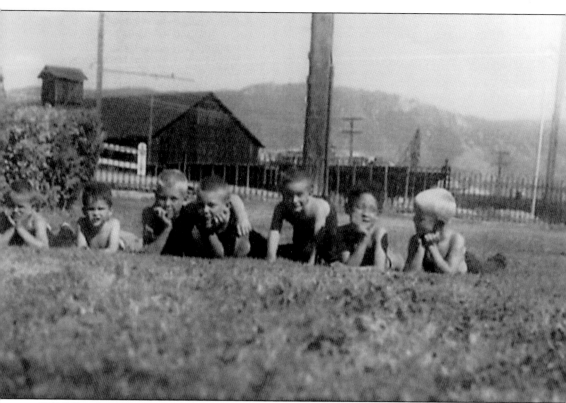

Bill "Chunky" Thatcher titled this picture, taken in front of Porter's yard on North Main Street, "Once Upon a Time in America." According to Thatcher, there were no better times growing up in Butte than those in the St. Mary's Parish area. Pictured from left to right are Jim Daly, Mike Thatcher, Bobby Thatcher, Dan Daly, Jack Daly, Bobby Ramirez, and Bill "Chunky" Thatcher. (Courtesy of Reggie Daly.)

Tim and Kathleen (Downing) Harrington, neighbors from Allihies Parish in County Cork, Ireland, married in Butte. Together they raised six children, shown above from left to right, Vic, Tim, Charles, Bill, Mary Francis (Trafford), and Catherine (Dunlap). (Courtesy of Rita Harrington.)

Dr. Ned Staples was a beloved Butte surgeon and family physician for over 59 years. He was also a much sought after and cherished patron of the arts, an unmatched storyteller, master of ceremonies, and self-taught musician and singer. Ned married Ann Jane Shields and together they raised six children, Dan, Steve, Mark, Tom Sally, and Jim. Mark, a practicing attorney, wrote several enduring Butte anthems, like "Mining City Christmas" and "Our Lady of the Rockies." His concerts have sold out the Mother Lode Theatre eight times over 30 years, raising over $150,000 for Butte charitable and civic causes. (Courtesy of Mark Staples.)

Sophie Boyle Lyons married Charles Boyle in Butte after both had emigrated from Ireland. They had three sons. Charles worked in the mines. After Charles Boyle died, Sophie married Ed Lyons, who originally hailed from County Donegal and they had two sons together, Jim and Pat. Pictured here from left to right are Jim Lyons, Pat Lyons, Charlie Boyle, Sophie Boyle Lyons, John "Pug" Boyle, and Ed Boyle. (Courtesy of Jim Lyons.)

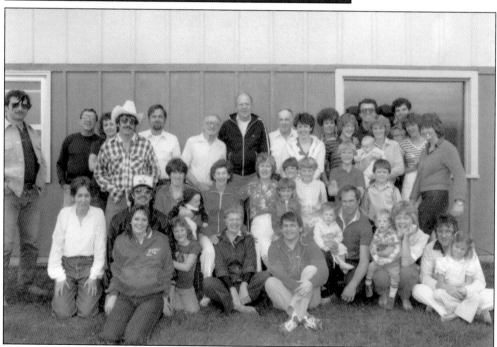

Children, grandchildren, and great-grandchildren of immigrants Michael Healy and Abbey "Bina" Harrington Healy gather for a family reunion in July 1981 in Butte. (Courtesy of Cherie Bowman Lyons.)

Born in Ireland, Rose Burns Lee and husband, Hugh Lee, came to Butte by way of Leadville, Colorado. They lived at 23 Corra Terrace, where they raised their nine children who attended St. Lawrence School. The sixth of the nine children, Robert Emmett, was given his name in memory of the Irish patriot. Five generations of the Lee family call Butte home and have served the Butte community as policemen, commissioner, police judge, and fireman. (Courtesy of Joe Lee.)

St. Patrick's Church was erected in 1884. Pastors through the years have included Fathers Dols, Tremblay, Van de Ven, DeSiere, Venus, McCarthy, Hunthausen, Byrne, O'Neil, McGurk, Fortney, Butori, Christoferson, Vernon, and Hall and Monsignors English and Gilmore. Shown here is St. Patrick's School. (Courtesy of Helena Diocese Archives.)

St. Lawrence Church was erected in 1896. Pastors through the years have included Fathers Batens, Leonard, MacDonald, McCormick, Harrington, McCarthy, O'Sullivan, and O'Neill. (Courtesy of Helena Diocese Archives.)

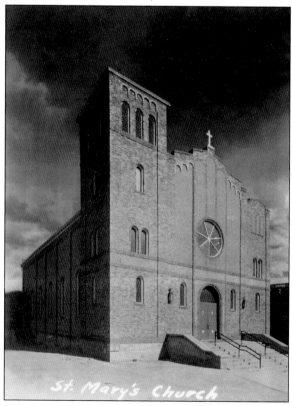

The original St. Mary's Church was erected in 1903. In 1931, a fire destroyed the church and a new one (shown at left) was built on North Main Street. Pastors through the years have included Fathers English, McCormack, Hannan, Nolan, Rooney, Gilmore, Sheerin, Brown, Gerner, Molloy, O Sullivan, and O'Neill. (Courtesy of Helena Diocese Archives.)

The original three-story St. Mary's school, constructed in 1916 on Wyoming Street, was replaced in 1951 with this building constructed in the Stewart Mine yard. Students from Anaconda Road, Dublin Gulch, Corktown, Sunnyside, Muckerville, and Virginia Street attended school here. (Courtesy of Don and Wilma Puich.)

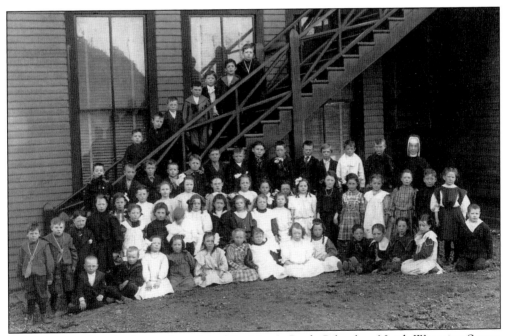

This is a second-grade class at the original St. Mary's Grade School on North Wyoming Street. (Courtesy of Colleen Lavelle.)

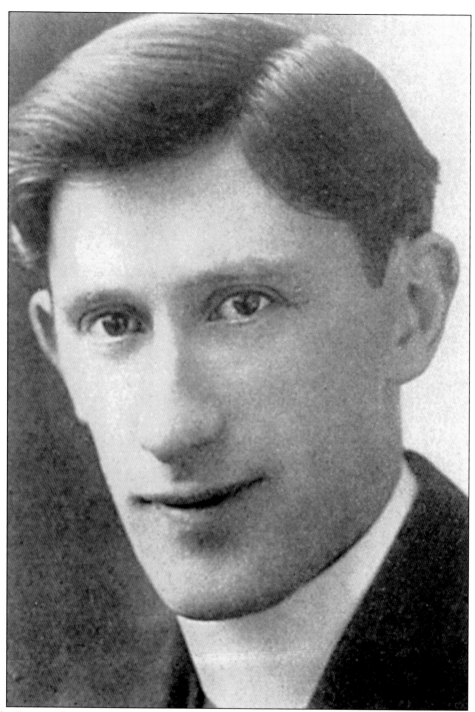

The Reverend James P. O'Shea left his home in Kilarney to come to Montana in 1915. Besides his duties as assistant at St. Mary's Parish, Fr. James P. O'Shea managed the 1919 Boys Central football team that included Pat Kane, Don Sullivan, Buck O'Donnell, Bart Riley, Mervin Dempsey, Jim Peoples, Gene Harvey, Lefty Carroll, Mike Walsh, Sas Keane, and Bert Mooney. (Courtesy of Tracy Thornton.)

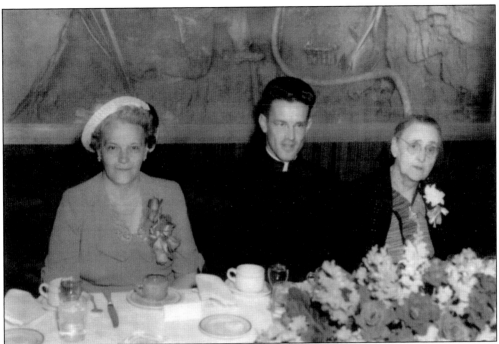

Fr. Jim Barry celebrates his ordination on May 19, 1951, at a breakfast at the Finlen Hotel. In this photograph are, from left to right, his mother, Helen Barry, Father Barry, and his grandmother Mary Barry. (Courtesy of Barry family.)

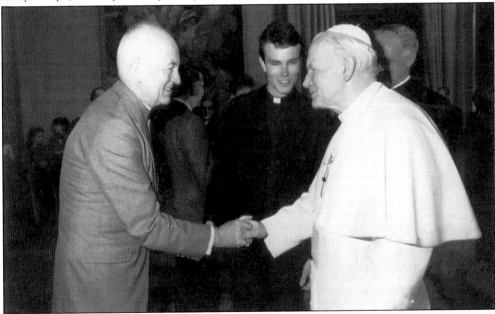

Beloved and respected throughout the Helena Diocese and the Butte community, Fr. Sarsfield O Sullivan is shown at an audience with Pope John Paul along with young Fr. Greg Smith. Father Sarsfield was known for his knowledge of Irish history and Butte genealogy. In his beautiful sermons, Father Sars combined his Irish wit and Catholic faith into an endearing lesson. (Courtesy of the O Sullivan estate and Colleen Lavelle.)

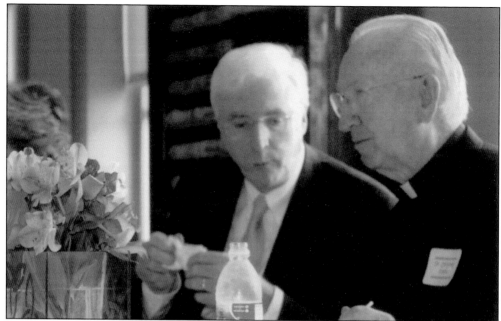

Fr. Gregory Burke was born in Bandon, County Cork, Ireland, and came to the United States as a young man to finish his seminary work in Seattle. Father Burke has educated many regarding Irish history, in particular, their long-fought battle for freedom. His years in the clergy have served the Butte community well. Pictured here with Ireland's ambassador to the United States, Michael Collins, at a breakfast in Butte, Father Burke is the embodiment of Butte Irish. (Courtesy of Julie Crowley.)

Fr. Robert Shea was ordained May 23, 1959. On May 24, 1959, Father Shea said his first mass at St. Mary's Church. In this photograph, Kay Shea receives Communion from her son, while her husband, John Daniel Shea, kneels next to her at the Communion rail.

Fr. Michael Driscoll graduated from Boy's Central High School in 1969. He is now a professor at the University of Notre Dame. Father Mike wrote of Irish president Mary McAleese's 2006 commencement speech at Notre Dame, during which President McAleese said, " I have come to South Bend by way of Butte, Montana, and the Butte people want me to convey to you they are big fans of the Notre Dame Fighting Irish. There are so many Irish Americans who have given back to the world, especially to Ireland." Father Driscoll said, "Listening to President McAleese, I was beaming inside to be a Catholic priest, an educator, and a native son of Butte." (Courtesy of Fr. Mike Driscoll.)

Fr. Ray Fleming graduated from Boy's Central in 1969. In 1983 (shown here) he officiated at the wedding of his brother Pat Fleming—son of Margaret and Ray Fleming—to Mary O'Leary—daughter of Gay and Bob O'Leary. Father Ray lives in New York, ministering to the hearing impaired. Also from this generation of Boy's Central, students are 1969 graduate Msgr. Kevin O'Neill and 1968 graduate Bishop George Thomas. (Courtesy of Pat Fleming.)

Helen Maher and Ralph Maher Walsh, raised by their grandma Cassie Doherty, are shown on Anaconda Road before their first communion at St. Mary's Church. Uncle Mickey Doherty told Ralph that the new suit "needs to last two years." (Courtesy of Cathy Doherty Shutey.)

From left to right, Barb Sullivan—daughter of Patrick and Lillian (Holland) Sullivan—and Ellen and Celine Regan—daughters of Emmet and Celestine Regan—pose for a picture before May crowning ceremonies at St. Mary's Church. (Courtesy of the Emmett Regan family.)

Julie Malvey (front center), mother Mary Downey Malvey, and Dolores Malvey are shown after Julie's first communion at St. Patrick's Church in 1942. (Courtesy of Dolores Malvey Paull.)

Mary Kay and Eddie Pat Moriarity, the daughter and son of Edward and Helen Moriarity, are shown in an official first Holy Communion picture. (Courtesy of Moriarity family.)

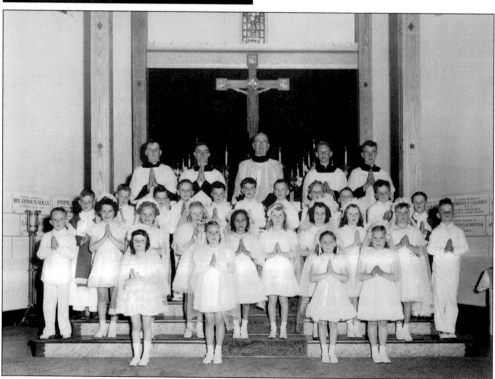

This is the St. Mary's communion class of 1952. (Courtesy of Emmett Regan family.)

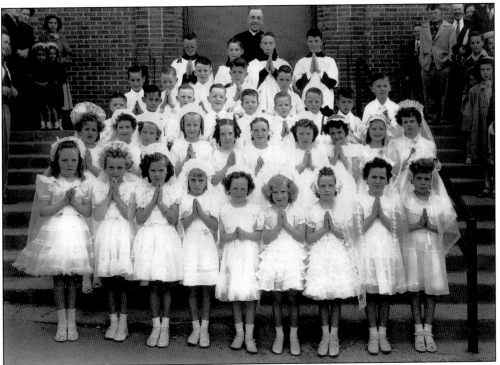

Taken on the steps of the church, this is the St. Mary's communion class of 1953. (Courtesy of Danette Harrington.)

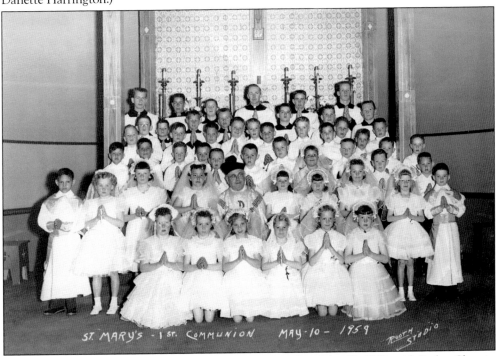

This photograph shows the St. Mary's first communion class, May 10, 1959, with Father Sheerin in the center. (Courtesy of Tim Hogart.)

Altar boy Billy Holland, son of Ed and Mary Holland, is at his home at 143 Ruby Street before serving Sunday Mass. Young Billy drowned at the Orfino ice pond in Brown's Gulch at age 12 in 1945. (Courtesy of Colleen Lavelle.)

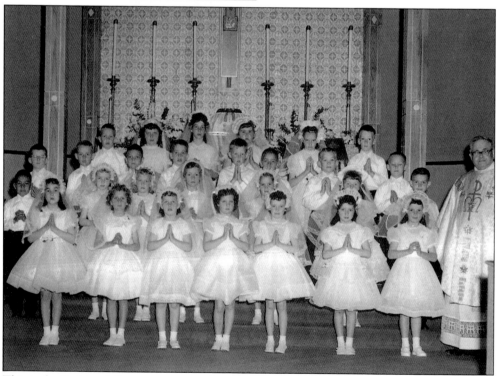

This is the St. Mary's first communion class of 1961. (Courtesy of Emmett Regan family.)

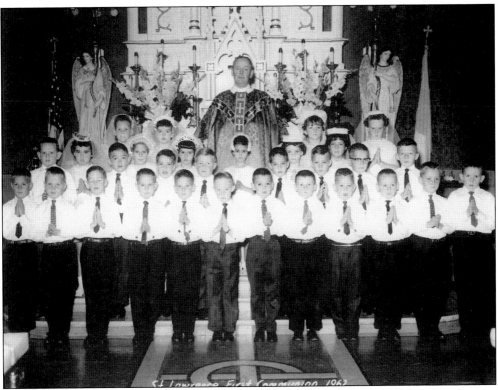

This is the St. Lawrence first communion class of 1962. (Courtesy of Mary Hubley Berg.)

The St. Mary's first communion class of 1971 included, from left to right, Julie Ann Crowley, Helen Connors, Bonnie McAuley, and Shirley Gross. (Courtesy of Julie Ann Crowley.)

"May Queen" Maryanne Shea is shown at the 1961 May crowning ceremony at the Immaculate Conception Church. (Courtesy of Ed Shea family.)

Shown above is St. Mary's eighth-grade graduation ceremony in 1928. (Courtesy of Emmett Regan family.)

Above is St. Mary's eighth-grade graduation class of 1932 (Courtesy of Enda Healy Bowman.)

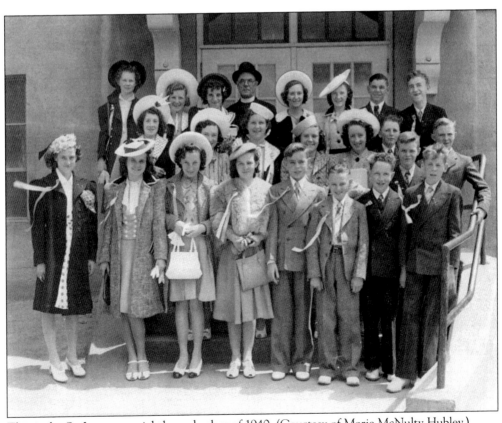

This is the St. Lawrence eighth-grade class of 1940. (Courtesy of Marie McNulty Hubley.)

From left to right, Helen Holland Lavelle (daughter of Ed and Mary Holland) and Pauline Sullivan Rebich (daughter of Pat and Lilly Sullivan) were part of the St. Mary's eighth-grade graduation class of 1945. (Courtesy of Colleen Lavelle.)

St. Mary's eighth-grade graduation class of 1936 is shown at right. (Courtesy of Rita McGee Melvin.)

This photograph shows St. Mary's eighth-grade graduation class of 1945 above. (Courtesy of Colleen Lavelle.)

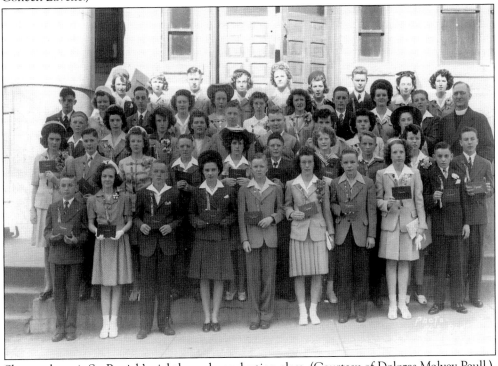

Shown above is St. Patrick's eighth-grade graduation class. (Courtesy of Dolores Malvey Paull.)

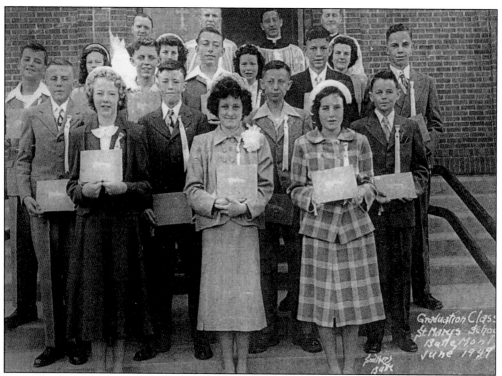

Smiling for the camera is St. Mary's eighth-grade graduation class of 1949. (Courtesy of Corrine Boyle Graham.)

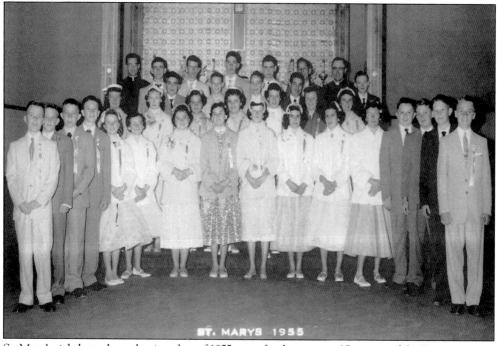

St. Mary's eighth-grade graduation class of 1955 poses for the camera. (Courtesy of the Emmett Regan family.)

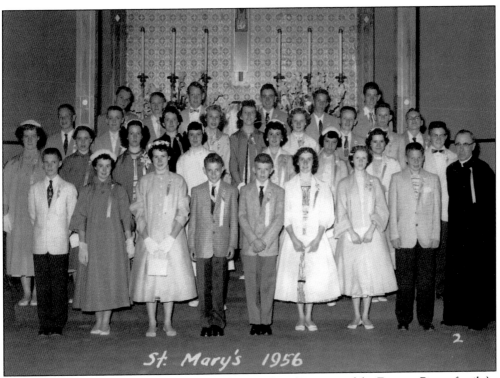

Shown in 1956 is St. Mary's eighth-grade graduation class. (Courtesy of the Emmett Regan family.)

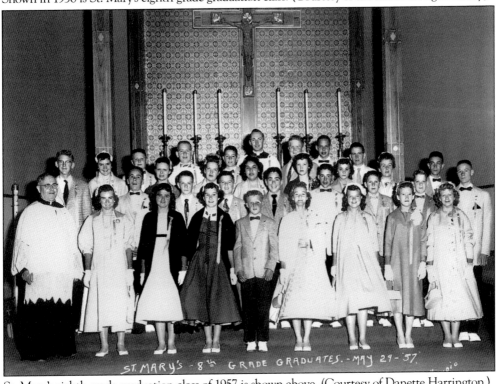

St. Mary's eighth-grade graduation class of 1957 is shown above. (Courtesy of Danette Harrington.)

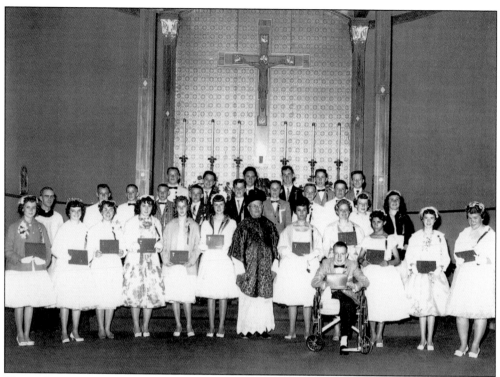

This is St. Mary's eighth-grade graduation class of 1961. (Courtesy of John Thatcher.)

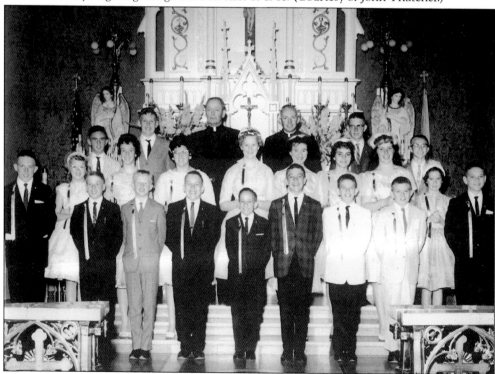

Shown in 1962 is St. Lawrence's eighth-grade graduation class. (Courtesy of Bernie Hubley.)

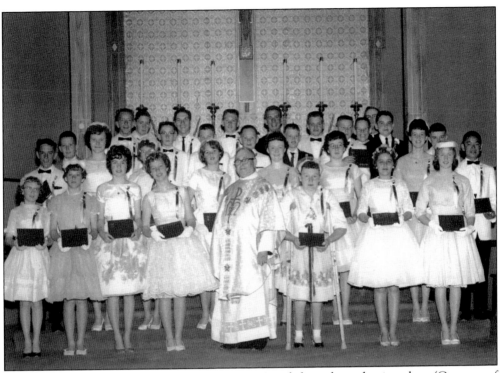

Shown in the 1963 photograph above is St. Mary's eighth-grade graduation class. (Courtesy of Bonnie Bowman McGowan.)

This is Immaculate Conception's eighth-grade graduation class of 1963. (Courtesy of Dan Shea.)

This picture is of the Immaculate Conception eighth-grade graduation class of 1964. (Courtesy of Peg Walters Stadler.)

Shown in St. Patrick's gym is the eighth-grade graduation class of 1966. (Courtesy of Lori Maloney.)

Shown in this picture is the St. Lawrence eighth-grade graduation class of 1966. (Courtesy of John Hubley.)

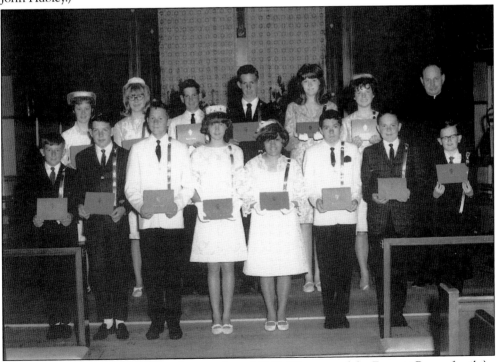

This is St. Mary's eighth-grade graduation class of 1967. (Courtesy of the Emmett Regan family.)

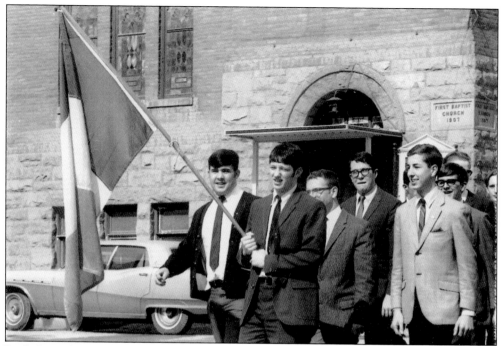

Boy's Central seniors, from left to right, Steve Jones, Mike Paul (carrying flag), Mike McDougall, Hugh O'Keefe, Dan Duffy, Bill Brennick, Tom Coyne, and Steve Kujawa, march in the 1969 St. Patrick's Day parade. (Courtesy of the *Montana Standard*.)

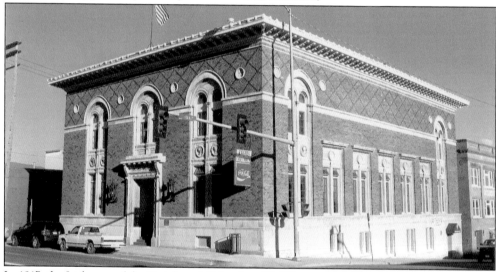

In 1917, the Irish arm of the Knights of Columbus (KofC) was the Ancient Order of Hibernians. The Catholic Youth Organization (CYO) was started in that same year. The KofC gym served the CYO for over 40 years, "advancing athletic talents and promoting good sportsmanship in Catholic youth." The CYO was also the start of many future marriages. The local CYO came to an end in 1969 with the closure of the Butte Catholic grade schools. Bernie Boyle has documented this incredible history with photographs through the years featured in the gym and workout area of the Knights of Columbus Hall. (Photograph by Maureen Bowman; courtesy of the Knights of Columbus.)

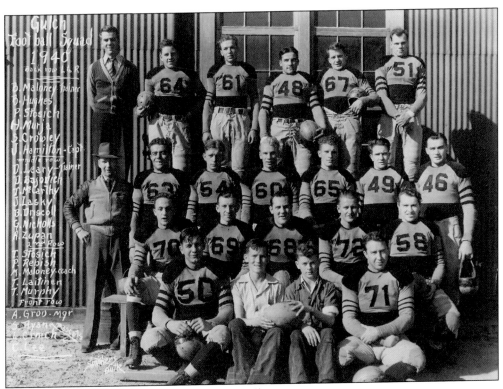

Pictured above is the 1940 Dublin Gulch football team.

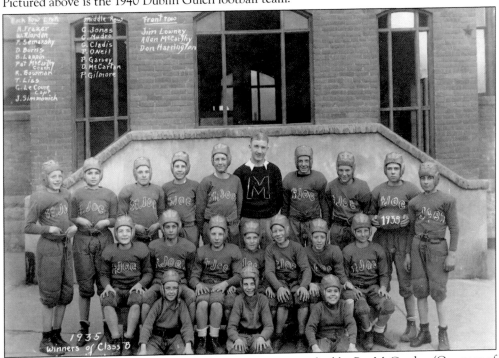

The St. Joseph's 1935 Class B football champions were coached by Pat McCarthy. (Courtesy of Richard Bowman family.)

St. Mary's basketball champions pose for a photograph. In this image are, from left to right, (first row) Father Mullin, Rich Barry, and John Murphy; (second row) Bill Callaghan and Emmett Thornton; (third row) Padrig Sullivan, Tim Crowley, Bernard Sullivan, John McGowan, and Dan O'Gara; (fourth row) Ray Driscoll and Bill Morris. (Courtesy of Tracy Thornton.)

St. Patrick's 1954 Class A basketball champions, shown above, were coached by Bill Dorr. (Courtesy of the Bill Dorr family.)

The 1946 St. Mary's Boxing Club is shown above. (Courtesy of Bernie Boyle, Knights of Columbus.)

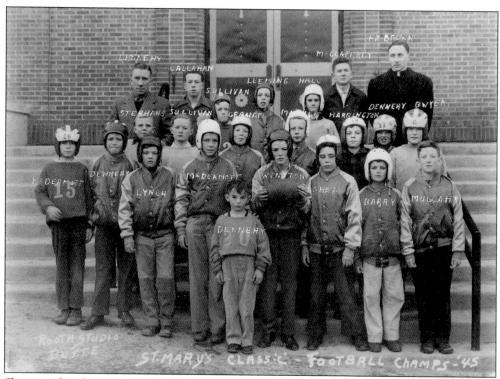

Shown in this photograph are St. Mary's 1945 Class C football champions. (Courtesy of Tom Kelly.)

This is the St. Mary's 1958 football team. (Courtesy of Ed Shea family.)

These are the St. Mary's 1961 city football champions. (Courtesy of John Thatcher.)

Posing for the camera is St. Mary's 1961 football team. (Courtesy of Mike McLaughlin.)

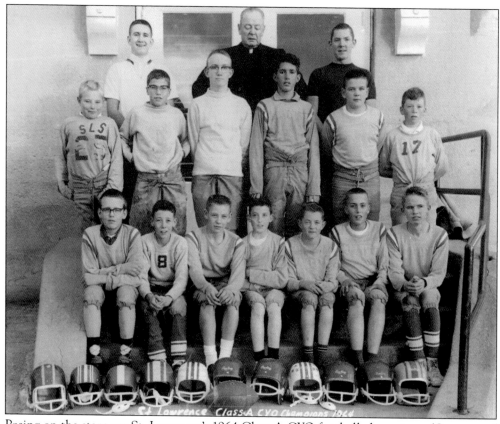

Posing on the steps are St. Lawrence's 1964 Class A CYO football champions. (Courtesy of John Hubley.)

At St. Patrick's playground in March 1966, seventh-grade students pose for the camera. (Courtesy of John Paull.)

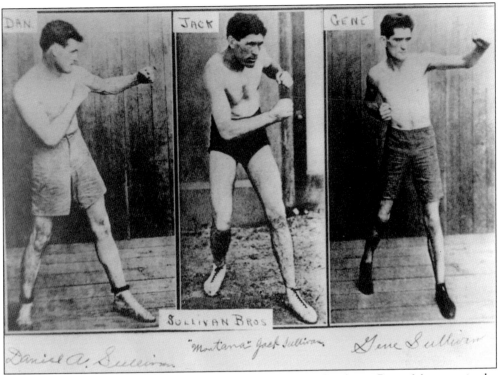

There were five Sullivan brothers who came from O'Neill, Nebraska, to Butte, Montana, in the early years of the 19th century. Four of the brothers—Jack, Dan, Gene and Jerry— were celebrated boxers in the Butte area, fighting in such venues as Luna Park. Brother Phillip worked as a cashier for the Anaconda Company. (Courtesy of the World Museum of Mining.)

Vonie (Healy) O'Brien (right) and Mary (Sullivan) Bender were childhood friends growing up in Muckerville and attending St. Mary's grade school. Both women, naturally athletic, had a love of water, spending much time at the YMCA to become accomplished swimmers and divers. Vonie O'Brien was inducted into the Butte Sports Hall of Fame in 2001 for winning two senior women state championships in 1932 and in 1934 just after giving birth to her son Dan. (Courtesy of Arlene and Tim McLean.)

"Jumping" Joe Kelly was raised in Muckerville. Joe attended Boy's Central and played basketball for the Butte Central Maroons. He set a single-season record in 1944 with 529 points. Joe was respected throughout the state for his remarkable ability and good sportsmanship. (Courtesy of Tom Mulcahy.)

Bill Harrington played guard and fullback (offense and defense) for the Butte High Bulldogs in the years 1932–1934. Bill and friend Alex Ducich, married to Irish lass Dorothy McCarthy, were the fourth and fifth persons to achieve Diamond B status, by celebrating 75 years since lettering for Butte High. Bill and his wife, Rita, raised six children and for 55 years owned Harrington's Restaurant at 40 West Broadway. (Courtesy of the Bill Harrington family.)

The CYO basketball champions of 1939 are, from left to right, Violet Rochelle, Jane Pipel, Jean Manning, Mable McCarthy, Enda Healy, and Marie Twomey. (Courtesy of Healy family.)

Butte's handball champion Joseph Bob Brady proudly wears the distinguished colors of the San Francisco Olympic Club. Brady first won the national handball championship by defeating Walter Plekan in Houston, Texas, in 1953. (Courtesy of Jack Whelan.)

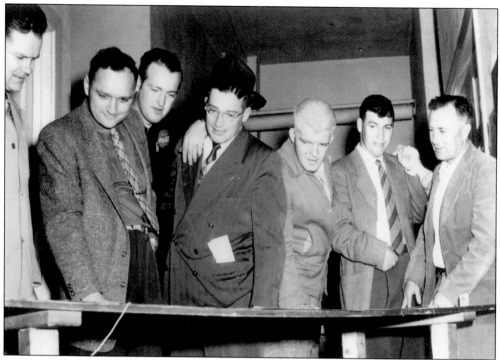

Gathering to take a look at the 1954 State Handball Tournament schedule are, from left to right, Jay Rydel, Jack Ritter, Jack Whelan, Ed Noonan, Mugs Walsh, Marvin Smith, and George Graham. (Courtesy of Jack Whelan.)

In 1937, Tom Lester was born the fifth of nine children to Marge and Joe Lester. He attended Catholic schools. He married Betty Jensen, and they raised four children. An exceptional athlete, Tom lettered four years in football and track and three years in basketball. He received a football scholarship to Marquette University. Tom was named Defensive Player of the Century by the *Montana Standard*. He spent his life teaching and coaching. (Courtesy of the Tom Lester family.)

Tom Mulcahy, son of Maurice "Dugga" Mulcahy and Catherine (Harrington) Mulcahy, was raised in Corktown in Butte, Montana. Tom attended Boy's Central High School and played basketball, winning three varsity letters. A gifted athlete, Tom's field of expertise was baseball. He loved the sport, securing a scholarship to Gonzaga University in Spokane. Later, this young Gonzaga baseball pitcher signed a Pittsburgh Pirates contract on the MGM set as fellow Gonzagan and part owner of the Pirates, Bing Crosby, gave a nod. After two years of pro baseball, Tom answered a religious calling, becoming a Jesuit priest. In 1969, the San Diego Padres announced the appointment of the Reverend Thomas Mulcahy as an association scout. (Courtesy of Tom Mulcahy.)

Bob McDonough Sr. started the Montana Amateur Speed Skating Association. Shown here in a race at the Butte civic center are Dick Haft (left) and Bob McDonough Jr. Bob skated in Madison Square Garden, tried out for the Olympics twice, and won the Chicago Silver Skates and speed skating championship. (Courtesy of Brendan McDonough.)

Mick O'Brien takes the 1963 Rocky Mountain Regional Golden Gloves middleweight championship and heads to Chicago for the national championship. (Courtesy of the Healy family.)

A breathing apparatus invented by Daniel D. Crowley, commissioned by the Anaconda Company, is currently displayed in the Orphan Girl Engine Room at the World Museum of Mining. (Courtesy of Lisa Warham.)

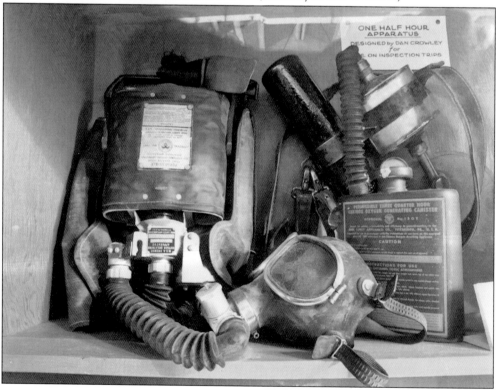

Maj. J. P. Foley was born in Ireland in 1856. After journeying to America, he enlisted with Gen. Nelson A. Miles to "make the Plains safe for the white man." Foley was present when Sitting Bull surrendered to General Miles at Fort Keough, Montana. Major Foley came to Butte to work on the Anaconda Hill and lived and raised his family in Walkerville with his wife, Julia. He died at 74. (Courtesy of Ethel Foley Lyons.)

Joseph Duffy, author *Butte Was Like That* and legislator and alderman from the First Ward, was born in Virginia City in 1877. Joe came to Butte in 1898 and established the Independent Laundry. His greatest claim to fame was as the originator of the Centerville ghost hoax of 1901. For almost 30 years, he kept the secret of the ghost to himself, no doubt smiling at the vast number of people that he fooled. (Courtesy of Mike Duffy and John Hughes.)

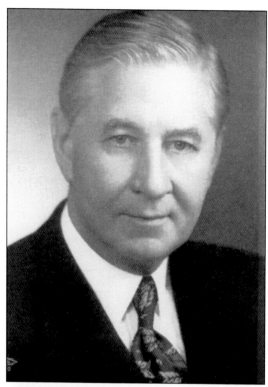

James E. Murray served Montana in the U.S. Senate as a Democrat from 1934 to 1961. Born a Canadian to immigrant Irish parents, he moved to Butte in 1897 and became a naturalized citizen at the age of 24. During the 1920s, Murray joined in the movement to secure American recognition of Irish independence from Britain. He worked with and accompanied Eamon de Valera during his visit to Montana. Later Murray served as president of the American Association for the recognition of the Irish Republic. (Courtesy of Maria Murray.)

Sen. James E. Murray is being honored on his 80th birthday in 1956. Present are five of his six sons. In this photograph are, from left to right, Howard A., Edward E., Charles A., William D. (a U.S. district judge), Senator Murray, and James. During his terms in the senate, he championed New Deal liberal legislation that included Social Security, the National Labor Relations Act, national health insurance, federal aid to education, and women's rights. (Courtesy of Maria Murray.)

John "The Yank" Harrington came to Butte at a young age; his parents, John and Katie Harrington, were immigrants from the Beara Peninsula. His father and mother died when he was quite young, and Harrington was sent back to Ireland to live with his grandmother. At 17, John worked his way back to Butte. He could never read music but learned to play the accordion, fiddle, and harmonica. He loved to dance but rarely had the chance. Harrington was a beloved and talented entertainer with a gentle spirit. (Courtesy of Tom Mulcahy.)

Barry O'Leary was born in Inchigila, County Cork, Ireland, and came to Butte in the early 1900s. After serving 24 years as Butte alderman, he was elected mayor in 1939. O'Leary married Honora Shea. Mayor O'Leary is shown here with Pres. Harry Truman on a visit to Butte in 1948. Barry's son Bob was Montana's U.S. attorney, appointed by Pres. Jimmy Carter. (Courtesy of Bob O'Leary family.)

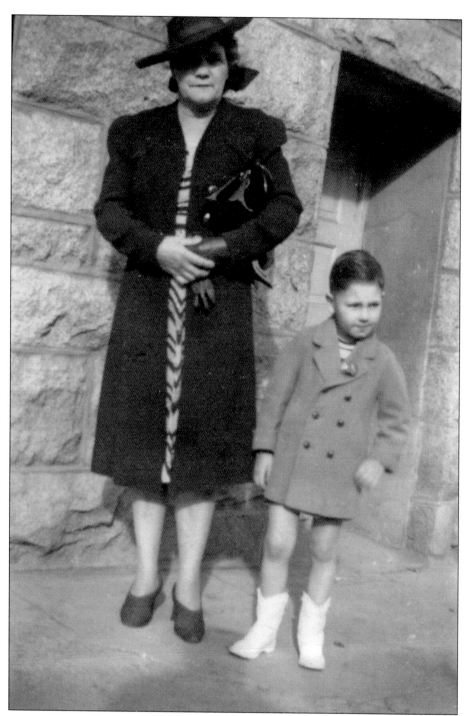

Future congressman Pat Williams is shown here with grandmother Lizzy "Goo" Keogh. It seems those boots were made for walking as Pat would serve as a Democratic member of the U.S. House of Representatives from the state of Montana from 1979 to 1997. After leaving Congress, Williams returned to Montana and became a professor at the University of Montana in Missoula. (Courtesy of Pat Williams.)

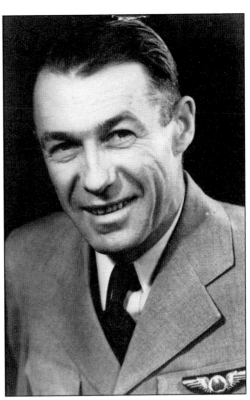

Bert Mooney moved to Butte from Billings, Montana, at a young age. He played football for Butte Central. As aviation gripped the young Mooney's imagination, he took lessons from Jack Lynch, the aviator who taught Charles Lindberg to fly. In 1935, Mooney made history by flying the first mail route into Yellowstone National Park. His commercial career began with Inland Empire Aerial and ended with Western Airlines, after which he and wife, Hannah Murray Mooney, moved back to Butte. All four of their sons—Al, Jay, Bill, and Brian—became pilots. Shown below boarding a plane for Salt Lake City, Utah, are Bill (left) and Brian Mooney. (Courtesy of Mooney family)

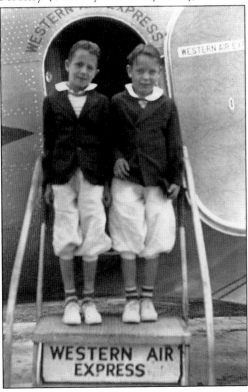

George McCarthy was a Butte native who was an appointee of three Democratic presidents—Kennedy, Johnson and Carter. He was one of the most influential Democrats in the state for almost 50 years and a close confidant of such illustrious political leaders as senators Mike Mansfield and Lee Metcalf. History books credit McCarthy and Sargent Shriver as the architects of Lyndon Johnson's first significant legislative action, the 1964 anti-poverty bill. Pictured here are Stan Kimmet, Sen. Bennet Johnston, Sen. Mike Mansfield, and George McCarthy. (Courtesy of George McCarthy family.)

Frank Quinn began his career as an office boy for the *Butte Daily Post*. Throughout his career, Frank received many prestigious rewards. He was privileged to interview Presidents Roosevelt, Truman, Kennedy, Johnson, and Nixon. Frank said Nixon gave the most interesting interview because Nixon was taking a shower in a room at the Finlen Hotel so the interview was in the buff. Frank was also a close personal friend of Sen. Mike Mansfield. (Courtesy of Frank Quinn family.)

Pat McCarthy, respected coach and teacher in the "Mining City," lead many teams to championships. In 1960, Pat left Butte for Washington, D.C., to serve in Congressman Arnold Olson's administration. When Congressman Olson left office, Pat McCarthy went to work for the U.S. Department of Defense. (Courtesy of Colleen Dzwinel and Tim, Jim, and Dan McCarthy.)

William J. (Babe) Maloney was a fine Irish tenor, a great bartender, an elected clerk of court, and an all-around charming gentleman. In 1966, Babe lost his leg to diabetes. Since he did not have insurance, the many friends Babe made through the years threw him a benefit party, which saw him through five months of recuperation. Babe Maloney loved Butte, and Butte loved Babe Maloney. (Courtesy of Lori Maloney.)

115

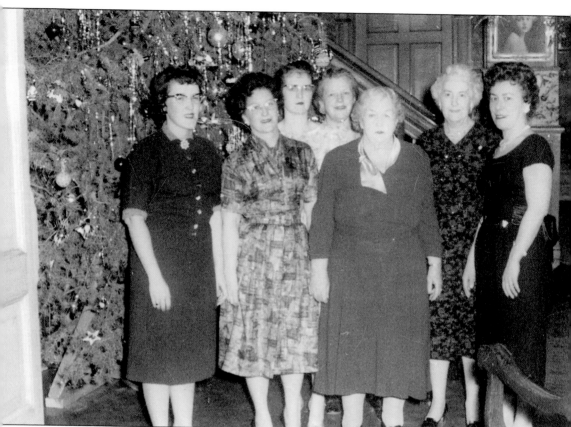

Ann Walsh Cote invested in real estate throughout the Butte area. She bought the Copper King Mansion in 1953 and spent her life collecting antiques and restoring the mansion to its glory days. Upon her death in 1964, her daughter Ann Cote Smith took over the mansion and worked with the historic society to have the house listed as a national historic site. Pictured here are, from left to right, Myrna Kitchen, Jule Nicholls, Patsy Nevin, Ann Cote, Theresa Nevin, Dolores Nevin, and Ida Guay. (Courtesy of the Cote family.)

From the time of the Copper King Wars, Butte has had a dramatic impact on Montana's legal community. Former Montana Supreme Court justices John Sheehy and Dan Shea, as well as current members Brian Morris and Mike McGrath, continue the tradition. Pictured in their judicial robes are, from left to right, Chief Justice Mike McGrath, retired associate justice "Skeff" Sheehy, and associate justice Brian Morris, all Butte Central graduates. (Courtesy of Eric Wordal's Master Piece Portraits.)

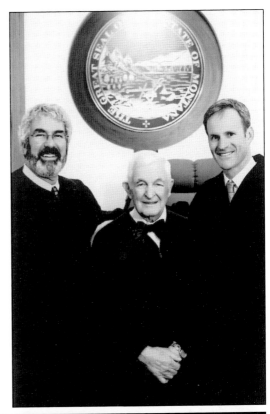

The Town Pump gas station enterprise of Montana was the brainchild of Mary and Tom Kenneally, whose family came the many miles to Butte by way of Ballyduff, County Cork, Ireland. The Kenneallys raised seven children, instilling in each of them the values of honesty, hard work, perseverance, and faith. Their hard work and generosity has benefited Montana in many ways including through the Town Pump Charitable Foundation. (Courtesy of Maureen Kenneally.)

Through the years there were many Irish Butte legislators, including Healy, Duffy, Sullivan, Reardon, Williams, Lee, Harper, Shugrue, Tracy, Good, Cooney, Lynch, Kelly, Daily, Driscoll, Shea, Beaudry, Keane, and Noonan. Pictured here is Sen. Jim Keane and wife, Dolores (who was born in Belfast Ireland), with grandchildren Mina and Brayden, walking and campaigning in the Fourth of July parade. (Courtesy of Keane family.)

Pictured above at the capitol on St. Patrick's Day are senators J. D. Lynch, Debbie Shea, Bea McCarthy (Anaconda), and Dan Harrington. (Courtesy of J. D. Lynch.)

Three

Leanúint na h-Oidhreachta
Continuing the Legacy

The sons and daughters of immigrants labored in the mines, organized trade unions, championed the cause of Irish Home Rule, lived their Catholic faith, took pride in their ethnic culture, and embraced Butte America as their new home—setting the stage for those who would follow. Today Butte celebrates its Irish heritage in a resumption of Irish music, dance, and language. Through the years, Butte Irish have intermarried, so the Irish surname is no longer an indication of Irish blood. In a town that embodies a mosaic of nationalities, Irish parades and festivals invite all of Butte's ethnicities to celebrate the Irish contribution. In all of its magic and imperfection, Butte is a product of those Irish immigrants who braved the New World so many years ago. For those Irish who stayed in Butte over the many years to work and raise families, Butte is forever home. For those Irish who left Butte to follow a career and visit on occasion, Butte is also forever home. And if an individual is Butte Irish, Ireland is forever imprinted on that person's soul.

Bryon and Brad Wilson are great-great-grandsons of James "Jim the Tadig" Harrington and Minnie (Sheehan) Harrington, great-grandsons of James and May (Harrington) Harrington, grandsons of Butte attorney Jim Harrington, and sons of Bryon and Jeanette (Harrington) Wilson. Bryon is a 2010 Olympic bronze medalist in freestyle skiing men's moguls, and Brad, a senior at Butte Central, is a 2009 Junior Olympics champion in moguls. (Courtesy of James Harrington.)

Pictured here is Dublin Gulch, a local Irish folk band that took its name from the expatriate Irish mining community. Members are, from left to right, Mick Cavanaugh, Tom Powers, Jim Schulz, and John Joyner. (Courtesy of Dublin Gulch.)

From left to right, Mary Kay (Shea) Hoy, Margie (Shea) McHugh, Kay Shea, and Tom Shea celebrate their Irish heritage at An Ri Ra in Butte. (Courtesy of Kay Hoy.)

Old neighbors Skeff Sheehy and Enda Healy Bowman, both raised on North Montana Street in the Muckerville district, enjoy a visit at the Friendly Sons of St. Patrick banquet. (Courtesy of Maureen Bowman.)

Jennifer Lynch, daughter of J. D. and Shannon Lynch, and Kane O'Neill, son of Joannie and Ed O'Neill, received the 2010 Friendly Sons of St. Patrick's academic scholarships. (Courtesy of Maureen Bowman.)

Shown here are three of the grand marshals of the 2007 St. Patrick's Day Parade—Dan Dolan, his daughter, Katie Rose Dolan, and Janet Lindh. Honored for their community work and efforts to ensure clean water for the Butte community, these individuals and several others received a warm reception from grateful citizens. (Courtesy of Janet Lindh McDonald.)

Gene Fogarty, retired schoolteacher and longtime Butte sports coach, was named grand marshal for Butte's 2009 St. Patrick's Day parade. Fogarty was inducted as an individual into the Butte Sport's Hall of Fame and was also voted into the hall of fame with his Central football team. Gene is married to Marjorie (Strnod) Fogarty and they have three children and seven grandchildren. Pictured celebrating St. Patrick's Day are, from left to right, (first row) Tommy, Haley, and Abby Mellott; (second row) Gene Fogarty, Margene (Fogarty) Dionysiou, Margie Fogarty, Dina (Fogarty) Mellott, and Shane Mellott. (Courtesy of Fogarty family.)

Celebrating a beautiful St. Patrick's Day in 2006 are, from left to right, Sarah Crain, Brian Harrington, Joan Shannon, Patrick Crain, Margaret Shannon Harrington, Kevin Shannon, Grand Marshall Ellen Shannon Crain, Gordon Crain, and Jackie Shannon De Wolfe. (Courtesy of Shannon family.)

In the Washington, D.C., area, Patrick, Bill, Theresa, Billy, Wendy, Mary, Hannah, and John Fischer, pictured from left to right, are celebrating their Catholic faith, honoring their Irish heritage, and missing Butte America. (Courtesy of Colleen Lavelle.)

Shown at a press conference for Irish and local press during President McAleese's visit to Butte are, from left to right, Brendan McDonough, Irish president Mary McAleese, and Martin McAleese. (Courtesy of Doug Loneman.)

Amanda and Quinn Shea are pictured exploring the ruins of their great-grandmother Abigail "Bina" Harrington Healy's home in Ballinacarrige, Allihies Parish, County Cork, Ireland. (Courtesy of Debbie Bowman Shea.)

Butte's Irish Tiernan dancers are, from left to right, Kasey McCarthy, Ashley Sims, Elsa Janey, Rachel Hyle, Briene Marinovich, Ciera Dauehauer, Kerry Powers, Desiree Dunbar, and Brieanne Scott. (Courtesy of Billie Marinovich.)

Enjoying a visit home to Ireland are Dolores Keane and children. Pictured at the Cliffs of Moher in County Claire posing from left to right for photographer Jim Keane are Lisa, Dolores, Kiely, and Kevin Keane. (Courtesy of Jim Keane family.)

Lori Maloney (left) and Danette Harrington visit Ireland and are shown here at Kylemore Abbey near Galway. (Courtesy of Lori Maloney.)

Emmett and Ann (Egan) Thornton enjoy a trip to Ireland, a gift from their children in honor of their 50th wedding anniversary. (Courtesy of Tracy Thornton.)

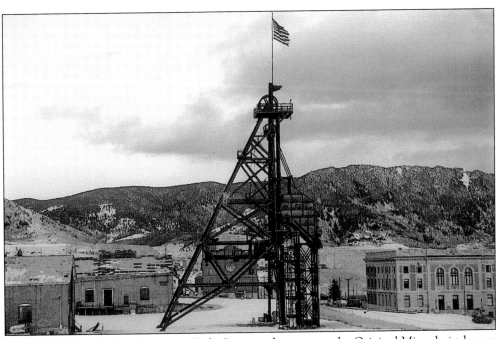

This photograph, by local lensman Cody Cavanaugh, captures the Original Mine, hoist house, St. Mary's Church, Federal Building (former post office), and the East Ridge, with Our Lady of the Rockies tucked in the snow. (Courtesy of Cody Cavanaugh.)

DISCOVER THOUSANDS OF LOCAL HISTORY BOOKS FEATURING MILLIONS OF VINTAGE IMAGES

Arcadia Publishing, the leading local history publisher in the United States, is committed to making history accessible and meaningful through publishing books that celebrate and preserve the heritage of America's people and places.

Find more books like this at
www.arcadiapublishing.com

Search for your hometown history, your old stomping grounds, and even your favorite sports team.